JACKSON POLLOCK'S *MURAL*

JACKSON POLLOCK'S *MURAL* THE TRANSITIONAL MOMENT

YVONNE SZAFRAN, LAURA RIVERS, ALAN PHENIX, TOM LEARNER, ELLEN G. LANDAU
AND STEVE MARTIN

THE J. PAUL GETTY MUSEUM, LOS ANGELES

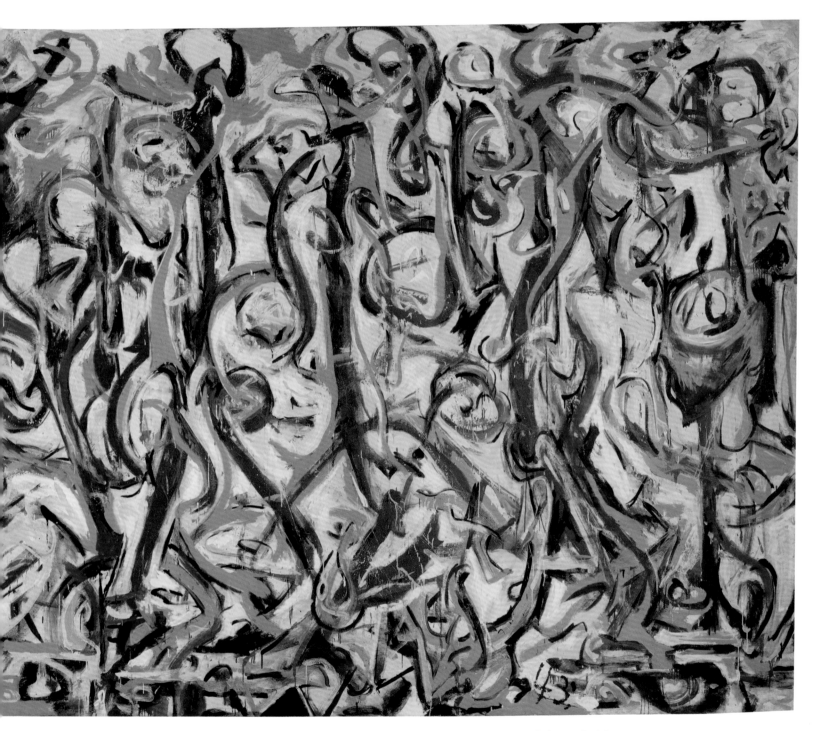

Jackson Pollock (American, 1912–1956), *Mural*, 1943.
Oil and casein on canvas, 242.9 × 603.9 cm (95⅝ × 237¾ in.).
University of Iowa Museum of Art

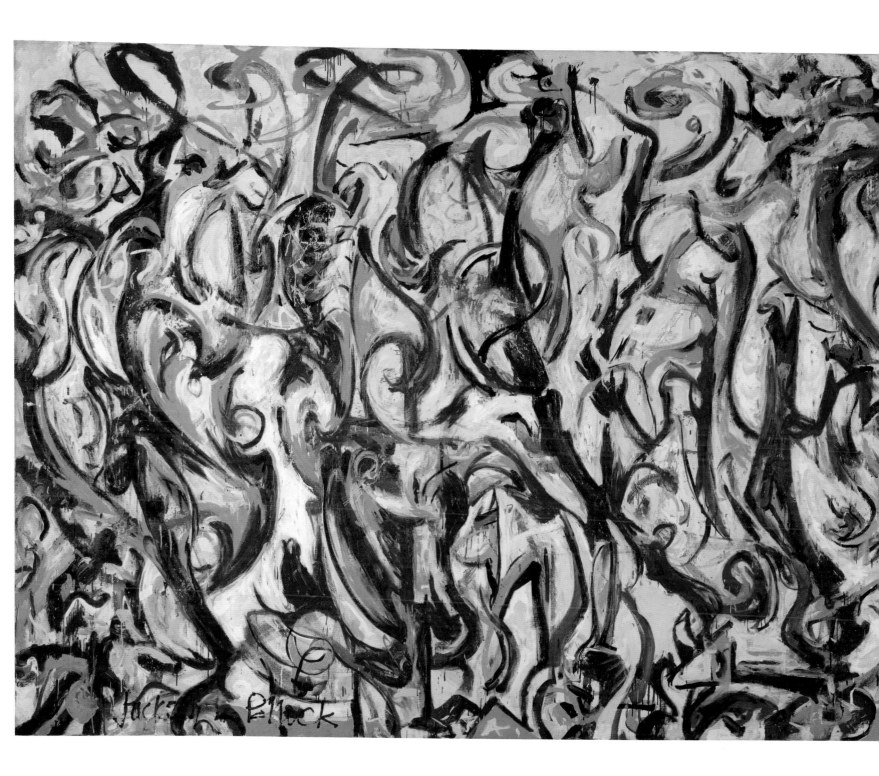

CONTENTS

FOREWORD

For over ten years, the Getty Conservation Institute (GCI) Modern Paints project—now part of the broader and more ambitious Modern and Contemporary Art (ModCon) Research Initiative—has developed improved analytical methods for identifying paint types and understanding how they perform. At the same time, the J. Paul Getty Museum's (JPGM's) Paintings Conservation Department has had a long-established program of collaborating with other institutions, bringing important paintings from around the world for conservation, study, and display at the Museum, and the Getty Research Institute (GRI) has developed among the world's most important archives for the study of modern and contemporary art. When in June 2009 the Getty was approached by Pamela White, then interim director of the University of Iowa Museum of Art in Iowa City, and asked if we would consider analyzing and treating Jackson Pollock's *Mural* (1943), we jumped at the chance.

Pamela White first met Tom Learner, head of GCI's ModCon Research Initiative, when she attended the Getty Leadership Institute during the summer of 2007. A year later, the Iowa River overflowed and flooded the University of Iowa Museum of Art, thereby prompting the collection to be stored off-site or to be relocated to a temporary display space at the Figge Art Museum in nearby Davenport. Pam and her colleague Sean O'Harrow, then executive director of the Figge, saw an extraordinary opportunity. They knew Pollock's painting was in need of full conservation treatment. Its surface had been significantly dulled by the aging of a varnish applied in the 1970s, and a sag in the canvas needed to be addressed. In 2010, when Sean became director of the University of Iowa Museum of Art, he continued to pursue this endeavor with matching enthusiasm. The painting arrived at the Getty in July 2012.

The presence of the painting in the JPGM's paintings conservation studio prompted our inviting artists, actors, and writers, including John Baldessari, Ed Harris, Steve Martin, Charles Ray, Peter Sacks, and Richard Tuttle, to examine the painting with us. And with the assistance of a generous grant from the Andrew W. Mellon Foundation, we met with conservators with special knowledge and experience of paintings by Pollock and his contemporaries and/or large paintings that have had structural histories similar to *Mural*.

Our thanks go to all of those at the Getty who have participated in this important project, in particular, Yvonne Szafran, Laura Rivers, and Lauren Bradley at the JPGM's paintings conservation studio; Scott Schaefer, the JPGM's senior curator of paintings; Tom Learner, Alan Phenix, and Wendy Lindsey at the GCI; and Andrew Perchuk and Aleca Le Blanc at the GRI. Their dedication and expertise has resulted in our understanding more fully Pollock's *Mural*, nothing less than a radical reworking of his entire artistic project.

James Cuno
President and CEO
The J. Paul Getty Trust

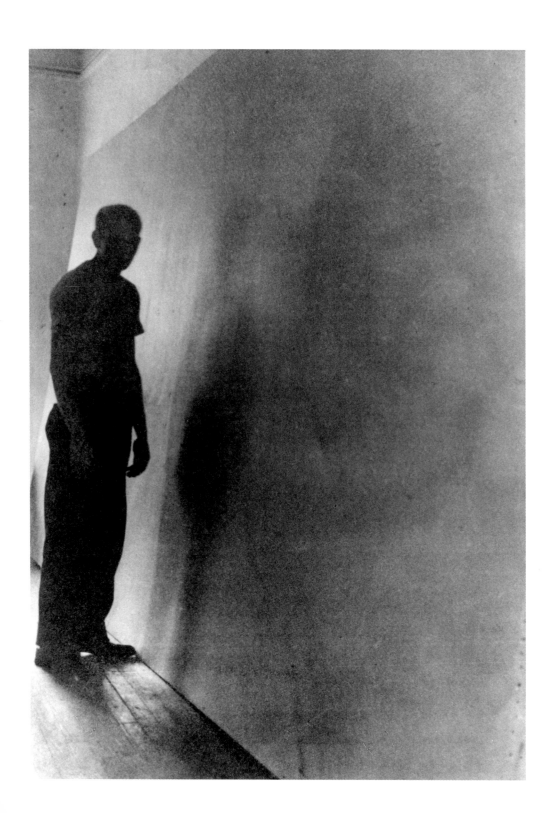

"THAT GODDAM SURFACE"

STEVE MARTIN

A CinemaScope blast of canvas, *Mural* debuted in Peggy Guggenheim's expansive hallway at a party after Pollock's gallery opening in 1943. I suppose Guggenheim thought if she was going to throw an art party, then she might as well do it with one of the strangest paintings 1943 had ever seen. The picture was viewed obliquely as guests carrying heavy coats passed beside it, heading for the cocktails necessary to endure the behavior of *Mural*'s creator, Jackson Pollock. While installing the painting, he had wandered into an afternoon party nude and drunk, with what may be called an extreme case of opening night jitters. *Mural* had the perfect rhythm for a party—or a nightclub, or a subway station—with vertical lines that were very nearly human dancing across what Pollock called "that goddam surface." Just four years later, those figures in his work would be gone, and he would have found in his drip pictures an expression of artistic emotion equal to opera's high C.

Guggenheim commissioned the picture, but I wonder what she was expecting. She was unsure about Pollock, but after he was endorsed by Mondrian and Duchamp—a formidable blue-ribbon panel—she gave him an exhibition and ordered a mural. If she was anticipating something akin to his recent work, she didn't get it. The pictographs that had been cropping up were missing, and taking their place were layer upon layer of swirling paint strokes—around thirty different colors in all. In another break, this time with art history, *Mural* was an "allover" painting. There was no central place to look, which was just as well since in the hallway there was no central place to stand, without stepping back into a fireplace that, it's been said, Pollock peed in.

Guggenheim immediately loved the painting, earning her extra credit for astuteness, especially when we consider that Picasso put *Les Demoiselles d'Avignon* in storage for years because no one gave a hoot about it, and seats for the opening night of *Oklahoma!* couldn't, literally, be given away. For Pollock lovers today, it's easy to rhapsodize about *Mural*, not only for itself, but as a proto-world that contains the genetic strands of Pollock masterpieces that were to come.

Bernard Schardt (American, 1904–1979), Jackson Pollock with the unpainted canvas for *Mural* in his Eighth Street apartment, summer or early fall 1943. See figure 21.

Mural's arrival announced a breakthrough by an artist who in the next few years would focus this moment to a finer and finer point. But Guggenheim could only evaluate *Mural* as an orphan without identifiable parents.

Works on canvas weren't yet that big, so calling this one a mural was fitting, but it's not really a mural, because it can be rolled up and taken away. It is, however, the first of the gigantic Abstract Expressionist paintings, because it is about size and paint. And in Abstract Expressionist pictures, size and paint are partners. Pictures that big hadn't been painted in a long while. Eighteenth-century French court paintings could be huge, but that's because everyone was *so important* and the artist had to get *everyone in* so they could *look admiringly at the king.* Size, in 1943, was the coming thing, and maybe, just maybe, *Mural*'s size reverberated in Pollock's head when, a few years later, he bought yards of yachting canvas and laid it on the floor, ready to make art history. I don't think there's an argument about whether *Mural* is an Abstract Expressionist painting. It's a little like arguing about whether Ringo Starr was a great drummer. Of course he was: he was the drummer for the Beatles. And, likewise, *Mural* is Abstract Expressionist because it was painted by Jackson Pollock.

Pollock's life's work is a fantastically vivid record of alternating struggle and triumph. In MoMA's chronological retrospective of 1998, one could follow along with the artist's output, which would escalate every few years into crystalline perfection, then devolve and amble while he worked out the next stop on his artistic journey. When he finally laid the canvas on the floor and walked around it, his muscular body stalking it, cigarette dangling, dripping paint in loops and arabesques, he must have felt liberated from the life drawing classes that had tormented him. He now made a drawing in the air, and the canvas intercepted it. He knew he was the first person who had ever done this, but he also knew how to make a painting, so the technique never overwhelmed the result. For the next few years, his vision, method, and impeccable judgment of his own work were at one.

But drip pictures are an art historical dead end. No one else can make them. That is, not without looking like a thief. Once Pollock had come to the end of drip paintings, and the elation he felt from them had subsided, there must have been a crisis. He even attacked one that was troubling him with a two-by-four dipped in blue paint—and took it into masterpiece category (the result was *Blue Poles)*. Abandoning the physicality of dripping, returning to the paintbrush, and knowing he had to rediscover himself yet again had to be daunting. A return to alcohol was called for.

It's too bad peace of mind isn't the reward of artistic accomplishment. Maybe Pollock wouldn't have had to die so recklessly, taking a young girl with him.

The world is fortunate that Duchamp was convincing in his efforts to have *Mural* painted on canvas rather than on a wall. It no doubt would have given way to a Manhattan decorator's wrecking ball. *Mural* bounced around in shows after Peggy Guggenheim took off permanently for Venice. Its size made it unsuitable for private collectors, so institutions took it in and cared for it, and it eventually settled in at the University of Iowa, where it can be contemplated by the lucky student body and faculty. At the Getty, the reputation of *Mural* has been solidified along with its foundation; the conservation department made sure that its great weight of paint won't slide off the canvas in slabs. I was fortunate to see *Mural* in the restoration area, coincidentally next to a Rembrandt self-portrait and a Giotto triptych. It was well hung.

MURAL: A TIMELINE

1943

July: Peggy Guggenheim commissions Jackson Pollock to paint a mural for the entrance hall of her five-story townhouse at 155 East Sixty-First Street in New York City.

July 15: Pollock notes in a postcard to his wife, Lee Krasner, "Have signed the contract and have seen the wall space for the mural—it's all very exciting."

July 29: Pollock writes to his brother Charles that the canvas has been stretched for Guggenheim's mural, that he is going to paint it in oil, and that he has torn out the partition between the front and middle rooms of his and Krasner's Eighth Street apartment to make space for it.

July or August: Pollock is photographed by Bernard Schardt next to the blank canvas for *Mural* (see fig. 21).

November 12: Guggenheim writes to Emily [Mimi] Coleman Scarborough indicating that *Mural* has been completed and installed and that a party has been held in Pollock's honor.

1944

January 15: Pollock writes to his brother Frank, "I painted quite a large painting for Miss Guggenheim's house during the summer— 8 feet × 20 feet. It was grand fun."

1945

March 19: Opening-day visitors to Pollock's show at Guggenheim's Art of This Century gallery are invited to view *Mural* from 3 to 6 p.m. at 155 East Sixty-First Street.

June 25: Manny Farber reviews *Mural* in the *New Republic*, calling it "an almost incredible success."

1946

In *Out of This Century: The Informal Memoirs of Peggy Guggenheim*, Guggenheim publishes the legend promoted by Krasner (and supported by the painter John Little) that *Mural* was created in one evening of frantic activity on December 31, 1943.

Fall: George Karger photographs Pollock and Guggenheim and her dogs at home in front of *Mural* (see fig. 19).

1947

Between January and April: Herbert Matter photographs Pollock in front of *Mural* at Vogue Studio (see fig. 25).

April 1 through May 4: Mural is shown in the exhibition *Large-Scale Modern Paintings* at the Museum of Modern Art, New York.

April 2 and 6: Mural is mentioned in reviews in the *New York Times* and the *New York Herald Tribune.*

Summer: Mural is lent to the Yale University Art Gallery.

Summer: In an (unsuccessful) application for a John Simon Guggenheim Foundation artist's grant, Pollock cites *Mural* as a precedent for his intention to "paint large movable pictures which will function between the easel and mural."

1948

October 3: Guggenheim writes to Lester Longman, head of the art department at the University of Iowa, offering to donate *Mural* to the university collection.

November 1: Guggenheim asks Pollock's current dealer, Betty Parsons, for a valuation of *Mural* and subsequently rejects Parsons's estimate of $3,000 as too low.

November 29: Longman writes separate letters to Guggenheim and to George Heard Hamilton at the Yale University Art Gallery accepting the donation of *Mural.*

1951

June 28: Longman writes to Hamilton questioning why *Mural* has not been sent.

October: Mural arrives at the University of Iowa.

1956

August 11: Pollock dies in an alcohol-related automobile accident.

1961

February 13: Since she also gave the University of Iowa Pollock's *Portrait of H. M.* (1945), Guggenheim writes to Frank Seiberling suggesting that the university consider trading *Mural* for a 1928 painting by Georges Braque.

March 7: Seiberling, head of the university's art department, politely refuses the swap.

1967

Mural is included in the Pollock retrospective *Jackson Pollock* at the Museum of Modern Art, New York. Conservators express concern about the painting's condition.

1973

Mural undergoes conservation treatment in Iowa.

1978

Pollock's catalogue raisonné by Francis V. O'Connor and Eugene Victor Thaw features Krasner's version of *Mural*'s one-night genesis (also included in B. H. Friedman's biography, *Jackson Pollock: Energy Made Visible* [1972]).

1979

Guggenheim provides greater detail on the problematic installation of *Mural* in the third version of her autobiography, *Out of This Century: Confessions of an Art Addict*: "We had great trouble in installing this enormous mural, which was bigger than the wall it was destined for. Pollock tried to do it himself, but not succeeding, he became quite hysterical.... Finally, Marcel Duchamp and a workman came to the rescue and placed the mural. It looked very fine, but I am sure it needed [a] much bigger space."

1989

Steven Naifeh and Gregory White Smith, in *Jackson Pollock: An American Saga,* describe Pollock's recollection to the artist Harry Jackson (from a letter by Jackson to O'Connor, November 25, 1965) that he had been thinking of a Wild West stampede while painting *Mural* and that horses and other animals had been incorporated into early stages of its composition.

1999

Based on her examination of the topography of the painting, the conservator Carol Mancusi-Ungaro writes in *Jackson Pollock: New Approaches* that *Mural* was unlikely to have been created in one night.

2012

July: Mural arrives at the Getty Center in Los Angeles for technical study, conservation, and cleaning.

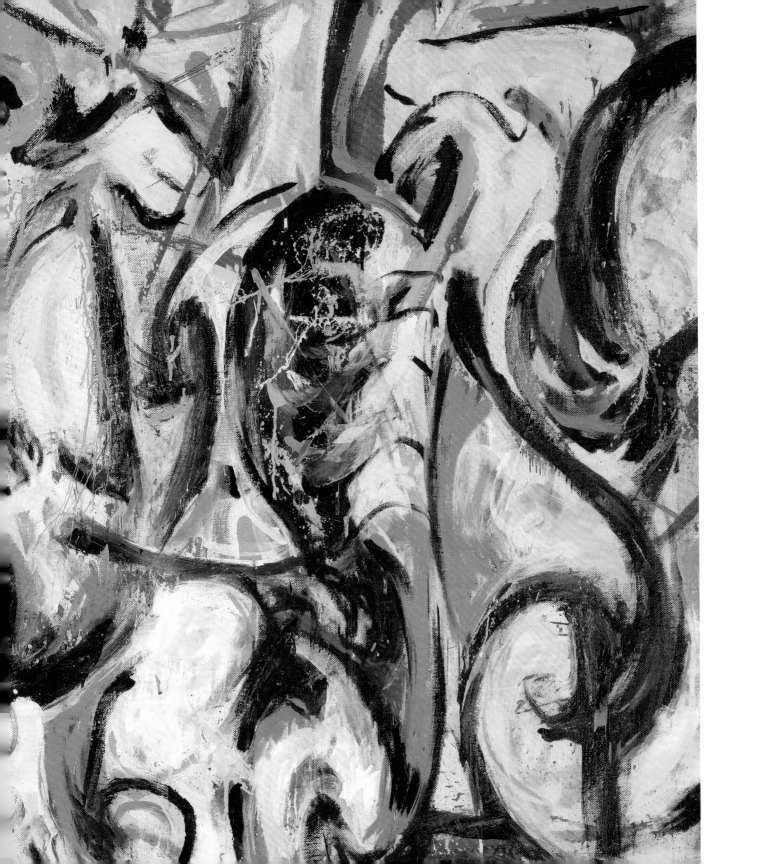

STILL LEARNING FROM POLLOCK

ELLEN G. LANDAU

> What may at first sight seem crowded and repetitious reveals on second sight an infinity of dramatic movement and variety. One has to learn Pollock's idiom to realize its flexibility.... I am, in general, still learning from Pollock.
> —Clement Greenberg, *The Nation*, April 13, 1946

The screen is labeled January 1947. We see a barn on Long Island, snow swirling. Jackson Pollock, played by the actor Ed Harris, wakes up and descends the stairs accompanied by his faithful dog Gyp. We see only Pollock's paint-splattered pants and shoes as he pads slowly down to the first floor of a Victorian farmhouse in The Springs near East Hampton, where he lives with his wife, the artist Lee Krasner. Krasner, played by Marcia Gay Harden, is on the telephone; we hear her asserting that, while no dealer will presently agree to represent him, her husband is "a great painter."

After Krasner hangs up the receiver, Pollock grabs his jacket and cap, taps his cigarette into an ashtray and puts it in his mouth, and accepts the coffee mug Krasner puts into his hand. Walking toward the barn, he sips his coffee and takes a drag of nicotine. He unlatches his studio door, lights a fire in the stove, and looks around. A small, unresolved painting with Surrealist-influenced imagery is moved to a horizontal position on the floor, and Pollock, using a brush, begins to paint out areas with silver-gray paint. Adding another log to the fire, he stares at what he has done, all the while stirring paint in a can. Some of it dribbles onto the floor as he thinks about what to do next. When Pollock notices the dripping white paint, he starts to pour on top of it. Flicking the brush, he adds a spatter pattern and glances more meaningfully at his canvas.

In the next scene of Harris's 2000 biopic (for which he received an Oscar nomination), Pollock's winter attire is gone, as is his tentative, semifigurative approach to painting. No longer working on a stretched canvas, he is dripping and pouring with confidence on a piece of cotton duck rolled out flat on the floor. It is so large he can actually step into it as he creates a rhythmically

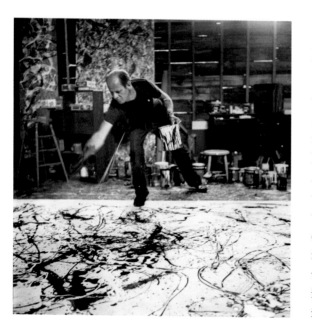

interwoven configuration of light blue, gray, white, and black skeins and splatters. Upon entering the house, Pollock is told that not only will the Betty Parsons Gallery take him on, but his former dealer, Peggy Guggenheim, has agreed to continue his monthly contract. With Gyp in tow, his wife goes out to the barn to check on what he has been doing. The scene ends with Krasner, shaking her head in wonder, exulting, "You've done it, Pollock. You've cracked it wide open."

Based loosely on a somewhat sensationalized 1989 biography, Harris's film plays to the general public's fascination with Horatio Alger accomplishments (little guy makes good) and tortured creativity, as well as its taste for simple epiphanies. A lightbulb seems to flash above Pollock's head when it dawns on him that if paint accidentally trickled on the floor makes such a nice pattern, why not deliberately drip it onto the canvas? No need to contend with fine craftsmanship, figuration, and other traditional (i.e., European) expectations of easel painting: what's required for fame and fortune in America is simply to follow your instincts.

Needless to say, while cut tragically short for the real Pollock, an artist's creative life and often complex path to aesthetic maturity can hardly be captured in the average time it takes to watch a movie. Although the segment described above—crucial to the elaboration of Harris's own hero worship of Pollock's achievements[1]—is pretty good theater, it seriously distorts how Pollock's authentic and influential allover poured paintings actually came into being (fig. 1). The "Hollywood" version of Pollock's artistic trajectory elides the critically important artistic sources he examined and digested as he developed his signature style. Despite little ongoing diminishment of interest in Pollock's oeuvre, not every step on this journey is yet completely clear. More than a half century after his death at age forty-four in an automobile crash less than a mile from his studio in The Springs, historians and curators are still actively parsing Pollock's tale. One fundamental step along the way, all seem to agree, was the artist's radical conceptualization of Guggenheim's *Mural* in 1943. Creation of this seminal work was also restaged in Harris's film—about which more to come.

Among the first to proffer a serious interpretation of Pollock's astonishing trajectory was the New York critic Clement Greenberg. In 1945, two years before Pollock's full augmentation of dripping pigment into an advanced compositional technique—he had already tried it out, including in *Mural*—Greenberg declared him "the strongest painter of his generation and perhaps the greatest one to appear since Miró." Upon seeing the young artist's first solo exhibition at Guggenheim's Art of This Century gallery in November 1943, Greenberg tried to determine the source of the "not so abstract abstractions" currently on view. "Pollock," he wrote, "has gone through the influences of Miró, Picasso, Mexican painting, and what not, and has come out on the other side at the age of thirty-one, painting mostly with his own brush. In his search for style he is liable to relapse into an influence, but if the times are propitious, it won't be for long." By 1947, the year that the graphic designer and photographer Herbert Matter captured Pollock standing in front of *Mural* (see fig. 25), Greenberg was already pronouncing him "the most powerful painter in contemporary America."[2]

FIGURE 2

Jackson Pollock, *Untitled [Composition with Figures and Banners],* ca. 1934–38. Oil on canvas, 27 × 29.8 cm (10⅝ × 11¾ in.). Houston, The Museum of Fine Arts, museum purchase with funds provided by the Brown Foundation Accessions Endowment Fund

As Maude Riley, another reviewer of his "explosive" first show so eagerly pointed out, Pollock had now moved well past the "conventional academic competence" of work created under the sway of his teacher, the Regionalist Thomas Hart Benton (fig. 2). Riley also mentioned Miró as a prototype, as did Robert Coates, who wrote in the *New Yorker,* "in Jackson Pollock's abstract 'Painting' [i.e., *Stenographic Figure*], with its curious reminiscences of both Matisse and Miró, we have a real discovery"[3] (fig. 3). While not specifically positioned as an influence, the British printmaker Stanley William Hayter was cited early on as a kindred spirit. Pollock's *Birth* was described in 1942 as "resembl[ing] Hayter in general whirling figures" (fig. 4). Six years later Coates classified both Hayter and Pollock as "symbolic Expressionists." This was around the time that—contrariwise—Greenberg had begun aggressively promoting him as a true heir to the classically based innovations of Analytic Cubism.[4] By 1947, basing compositional arrangements more on process than subject (the artist himself later expressed in his notes, "new needs demand new technics"),[5] Pollock's radical extension of the tenets of modernism seemed without precedent, even considering his global lineage.

The first monograph on Pollock was written only three years after his untimely death. In it, the poet-curator Frank O'Hara evidenced an acute understanding of the thrust (both literally

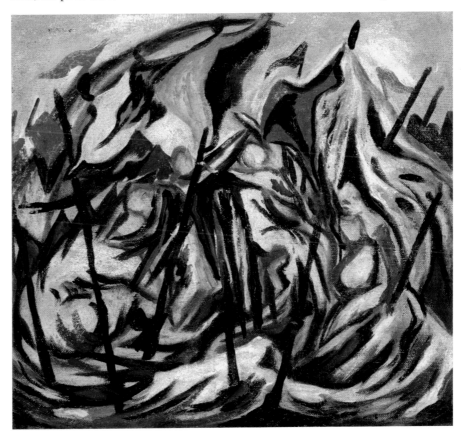

FIGURE 3
Jackson Pollock, *Stenographic Figure*, ca. 1942.
Oil on linen, 101.6 × 142.2 cm (40 × 56 in.).
New York, The Museum of Modern Art,
Mr. and Mrs. Walter Bareiss Fund

FIGURE 4

Stanley William Hayter (British, 1901–1988), *Combat*, 1936, published 1941. Engraving and etching, plate: 40 × 49.2 cm (15¾ × 19⅜ in.); sheet: 64 × 73 cm (25³⁄₁₆ × 28¾ in.). New York, The Museum of Modern Art

and figuratively) of his subject's prodigious talent. Analyzing the most innovative works Pollock produced during the decisive years 1947–50, O'Hara knew that he definitely hadn't been splashing and dripping in a random fashion, and the effects achieved in his best paintings little resembled those made by spilling paint on the floor and occasionally flicking a brush. While not conventionally delineating objects, O'Hara explained, Pollock *was* drawing (and drawing beautifully) nonetheless. "There has never been enough said," he wrote, "about Pollock's draftsmanship, that amazing ability to quicken a line by thinning it, to slow it by flooding, to elaborate that simplest of elements, the line—to change, to reinvigorate, to extend, to build up an embarrassment of riches in the mass by drawing alone." The artist's "quick, instinctive rightness of line," O'Hara noted, could be cool, passionate, heroic, ritualistic, dramatic, even arbitrary, depending on the picture. It could also sometimes be vulgar, a not generally appreciated effect for "high" art. But, as Greenberg elsewhere maintained, "what is thought to be Pollock's bad taste is in reality simply his willingness to be ugly in terms of contemporary taste." "In the course of time," he predicted accurately, "this ugliness will become a new standard of beauty."[6]

O'Hara also addressed directly another subject of primary significance to gauging the importance of Pollock's 1943 commission for Guggenheim: the matter of scale and its impact on the breakthrough nature of his feats. Pollock's stated aspiration, for which he himself cited *Mural* as a precedent, was the expansion of easel painting's aims and effects to the dimensions and objectives

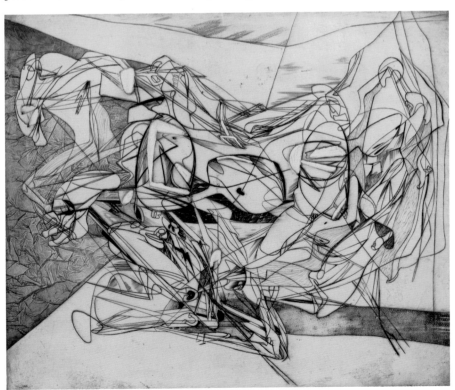

FIGURE 5

Thomas Hart Benton (American, 1889–1975), *Steel*, panel from *America Today,* 1930. Distemper and egg tempera on gessoed linen with oil glaze, 233.7 × 297.2 cm (92 × 117 in.). New York, The Metropolitan Museum of Art, gift of AXA Equitable, 2012.478a–j

FIGURE 6

José Clemente Orozco (Mexican, 1883–1949), *Prometheus*, central panel, 1930. Fresco, 762 × 914.4 cm (300 × 360 in.). Claremont, CA, Pomona College

of wall art. The latter was exemplified for him by the achievements of Benton (fig. 5) and Mexico's Los Tres Grandes, especially José Clemente Orozco and David Alfaro Siqueiros. Indeed, Orozco's *Prometheus* at Pomona College would remain a lifelong favorite (fig. 6). Hans Namuth's celebrated 1950 photographs of Pollock at work demonstrate exactly how this ambition was eventually achieved. Elaborating the aesthetic potential of body-centered (not wrist-centered) performance to execute his large-scale paintings, only four years after the completion of *Mural* Pollock would find an even more stunning and original way to meet his goals. As one reviewer so colorfully wrote at the first exhibition of his now-classic allover paintings, "items of billboard proportion are packed into one small room. The effect is dizzying.... Space is limited; Pollock apparently isn't"[7] (fig. 7).

In Pollock's case, O'Hara realized, size and scale are not necessarily synonymous. "Scale, that mysterious and ambiguous quality in art which elsewhere is a simple designation, has a particular significance in Pollock's work," he pointed out, "but it has nothing to do with perspectival relationships in the traditional sense or with the relationship of the size of the object painted to

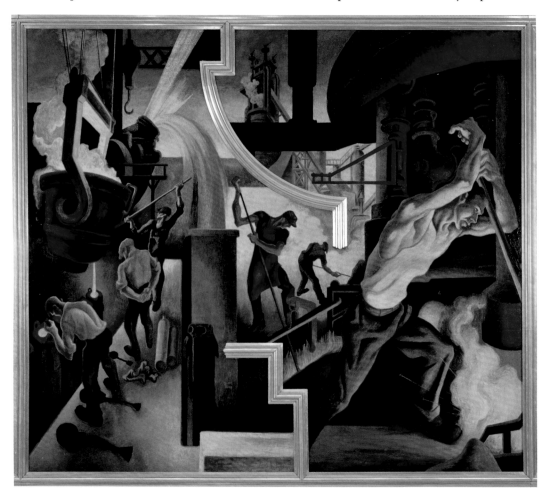

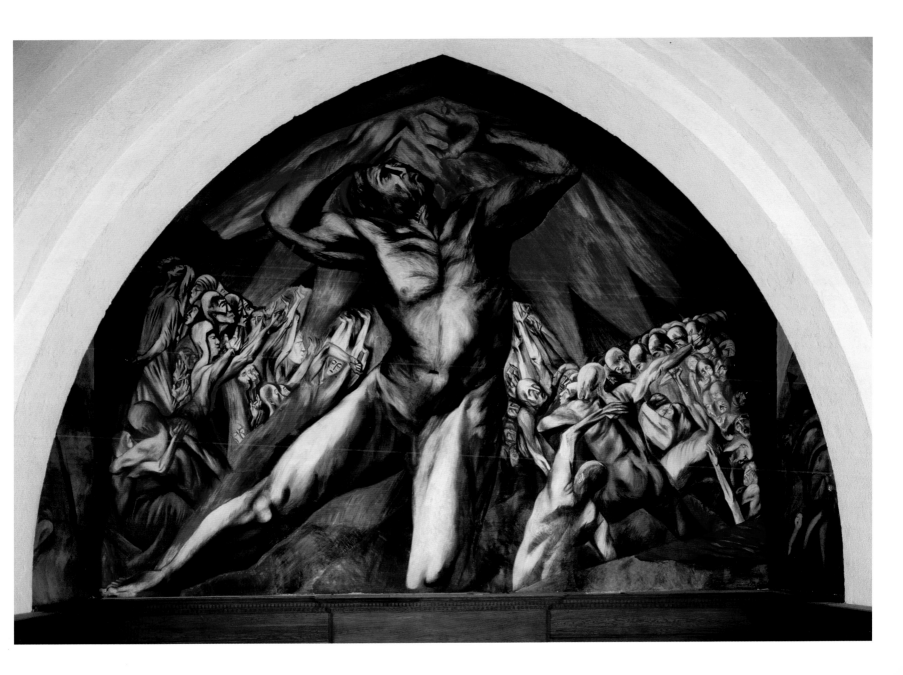

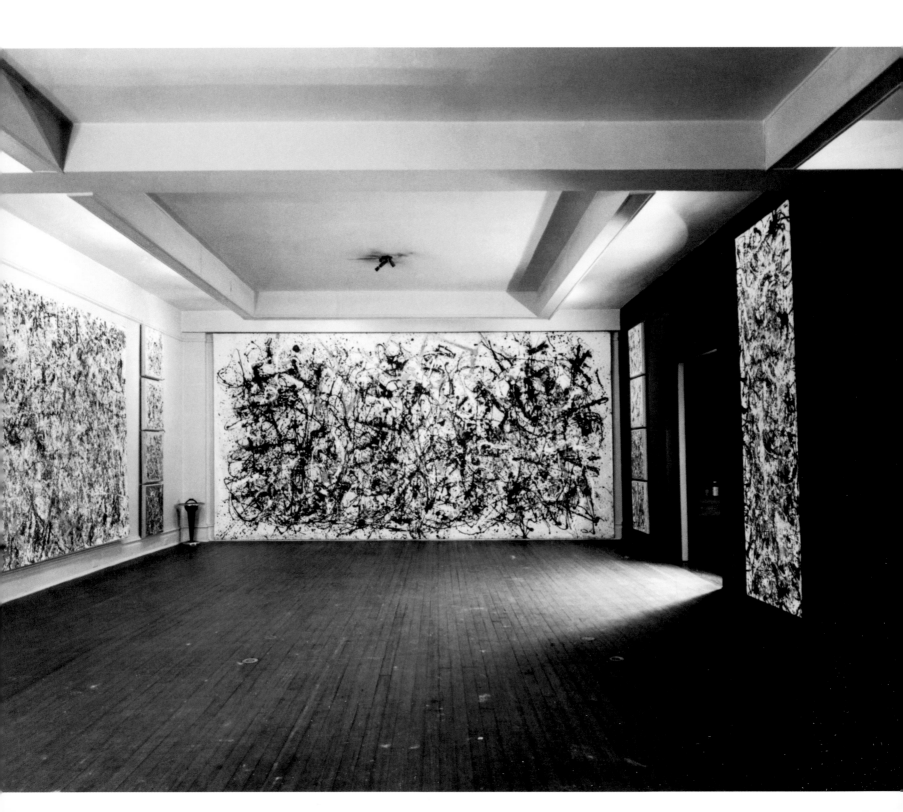

the size of the object in reality. It has to do, rather, with the emotional effect of the painting upon the spectator." Already hinted at in *Mural*, scale was to become a fundamental means for Pollock to express his "passion as an artist."[8] Ongoing discussions with Greenberg during the late 1940s contributed to his bolder move toward the paradigm-shifting "big" pictures presaged by *Mural*. By 1949, these were in steady production.

Lent confirmation by the 1978 publication of his catalogue raisonné, studies of Pollock's career have uniformly privileged the classic dripped and poured works, especially *Lavender Mist* and *Autumn Rhythm*, both painted in 1950. The installation of Pollock's 1998 retrospective at the Museum of Modern Art (MoMA) in New York, opening out from narrower galleries into a capacious, well-lit area where the allover works were hung so gloriously, underscored that perception. The show's design also reinforced assertions of Pollock's overarching importance made by William Rubin, MoMA's former director of sculpture and painting. In a series of articles called "Jackson Pollock and the Modern Tradition," Rubin concentrated on Pollock's use of European precedents for fulfillment of his own objectives. That Pollock's accomplishments went well beyond his sources hinged, as Clement Greenberg put it, on his desire "to tur[n] the picture, from an object, a cabinet painting, into a field area, a zone of vision."[9] Considering this Pollock's crowning achievement elevates the importance of *Mural* as his initial expansive experiment. While still friezelike in composition, more evenly filled in and densely layered as well as relatively homogeneous in texture and not yet fully automatic, Pollock's radical conception of an art comprising "no limits, just edges," is clearly presaged in this pivotal work.[10]

Despite his lack of education and well-known poverty of linguistic skills, according to Rubin, Pollock never "surrendered decision-making to mindless kinetic activity." Rather, he "grasped" with "acuity" exactly how a wide variety of enthusiasms and inspirations could be filtered, assimilated, and recontextualized to express his inner thoughts and reactions to contemporary life. For a man who had an especially hard time making and maintaining personal relationships, communing with those he admired through an inspired process of stylistic bricolage, a strategy already present in *Mural*, helped to sublimate these perceived inadequacies.[11]

Although he attached the highest value to Pollock's large poured paintings (the artist explained in 1950, "I'm just more at ease in a big area than I am on something 2 × 2; I feel more at home in a big area"),[12] Rubin was also careful to stipulate that "the notion of Pollock as a painter of primarily outsize pictures is contrary to fact." As Namuth's photographs indicate, larger and smaller, finished and in-process paintings were juxtaposed in Pollock's studio to create an ambience stimulating to further creativity (see fig. 1). While *Mural* is justly famous for introducing an outsize format, its composition engages issues pursued in a variety of sizes and ways.

The essence of Pollock's breakthrough has been linked to his finding a way to eradicate the difference between drawing and painting, projecting onto canvas the closeness to original impulse typically associated with a sketch. Eventually, he would allow process to replace appearance as his primary progenitor of form. "*No Sketches*," Pollock wrote in 1954, "acceptance of *what*

FIGURE 8
David Alfaro Siqueiros (Mexican, 1896–1974),
Collective Suicide, 1936. Lacquer on wood with
applied sections, 124.5 × 182.9 cm (49 × 72 in.).
New York, The Museum of Modern Art, gift of
Dr. Gregory Zilboorg

I do—," a stance underscoring the legend promoted by Krasner, that *Mural* was created in one frenzied night of activity.[13] While the origins of *Autumn Rhythm* and other allover poured works are apparent in Namuth's photos, Harris's inspired re-creation of *Mural*'s (technically unsupportable) genesis myth is all the more impressive since no similar documentary footage existed for the actor to study.

Examination of areas in *Mural* where directed spillage and splatter is clearly incorporated (some smaller compositions of 1943 include these as well) highlights the simmering impact of his 1936 participation in Siqueiros's Workshop on Union Square. Making political banners and floats there, Pollock came into contact with the Mexican's unorthodox painting techniques, including the use of commercial enamels and dripping, spraying, and spattering as a route to generate imagery and style (fig. 8). Study sessions at the studio of the Chilean Surrealist Roberto Matta in winter 1942–43, attended with Robert Motherwell and others, exerted additional pressure on Pollock's development of factural independence.[14] The autonomous line commencing in his works

FIGURE 9

Jackson Pollock, *Untitled (4)*, 1944–45.
Engraving and drypoint, plate: 38 × 44.8 cm
(14¹⁵⁄₁₆ × 17⅝ in.); sheet: 47.7 × 63 cm
(18¾ × 24¹³⁄₁₆ in.). New York, The Museum
of Modern Art, gift of Lee Krasner Pollock

circa 1947–48 might also be traced to learning to handle the printmaker's burin at Hayter's Atelier 17, located near the apartment where *Mural* was made.[15] Although Pollock's chief experiences there took place the year after *Mural*'s creation, he was familiar with Hayter's ideas before he began it. Based on a letter to one of his brothers, this was not in late December, as Krasner liked to recount, but sometime during the summer of 1943.

According to the art historian T. J. Clark, while "Pollock's art is one that aims constantly at a radical, incommensurable, truly elating scale, his bigness needed smallness in order to register as such." This insight raises the notion that artistic connections with Hayter might require greater scrutiny.[16] Founded in Paris in 1927 as "a workshop where equipment and technical assistance were available for artists wishing to experiment in graphic methods,"[17] Atelier 17 was moved to New York in 1940 in the wake of Hitler's conquest of Europe and the Nazis' suppression of modern art. While Pollock knew of Hayter by reputation in the late 1930s, they were introduced in Province-town in 1943 by Reuben Kadish, a mutual friend. Throughout the ensuing two years especially, Pollock and Hayter met frequently.

Hayter, who once appraised Pollock as "a man who *saw*, who *looked* at things," recalled his young friend's fascination with their talks about the unconscious as a source of inspiration and how to court obsessive imagery. According to Kadish, for a short while Pollock went at night to Atelier 17 to make experimental prints, hoping his images would "express more intensely" that way (fig. 9).[18] Following what he had learned about kinesthesia and muscularity from Benton at the Art Students League, and his observation of Siqueiros's improvisation with materials, Pollock was

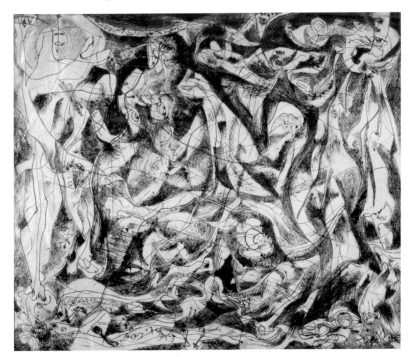

primed to admire Hayter's physical approach to artistic activity, which he seemingly mirrored in *Mural*'s execution. It was at Atelier 17 that Pollock could have witnessed the arbitrary generation of lines with a compound pendulum practiced by Guggenheim's husband at that time, the Surrealist Max Ernst.[19] And he likely came to realize that automatism can also be controlled, in part through Hayter's admiration for the art of Paul Klee.

Although Pollock ultimately desired a different kind of automatic line, one Hayter characterized as "charged with an extremely high voltage," Klee's calligraphic whimsy possibly affected Pollock's conceptualization of *Mural* (fig. 10). In it, he multiplied and set into motion a series of personages reminiscent of both Klee and Miró (fig. 11), turning leftward the facing figures positioned at the margins in *Guardians of the Secret* and other mythic compositions also painted in 1943 (fig. 12).[20] *Mural*'s striding figures are unmistakably prefigured in the central panel of *Guardians*, a fact more in evidence if turned upside down. Numerous totems featured in the latter picture,

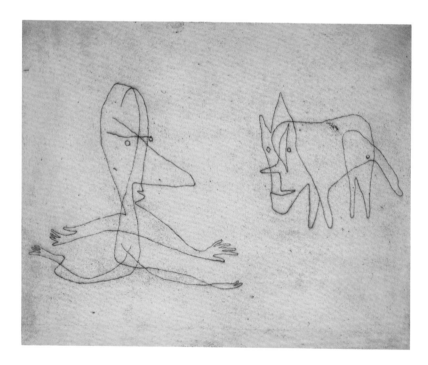

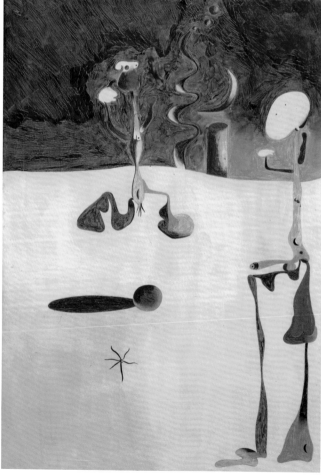

FIGURE 12

Jackson Pollock, *Guardians of the Secret*,
1943. Oil on canvas, 122.9 × 191.5 cm
(48⅜ × 75⅜ in.). San Francisco Museum
of Modern Art, Albert M. Bender Collection,
Albert M. Bender Bequest Fund Purchase
45-1308

FIGURE 13
Detail of *Mural* (bottom center) with a figure resembling a dog.

including several birds, a bird-headed shaman, a multilegged Mimbres scarab beetle (see p. 6), and a centrally placed Anubis-like reclining dog (fig. 13), make cameo appearances in *Mural* as well. Pollock's recollection that the long-ago experience of a wild-horse stampede had come to mind while he was painting *Mural* has led some to discern horses within its composition. It seems more likely, however, that he was making reference to the rising and falling energies of his composition, and the rush he had felt when making it.[21]

Talking with Hayter would undoubtedly have provided Pollock with added inspiration for his search beyond the usual techniques of painting. Decrying preliminary drawing, Hayter emphasized "the idea of an action undertaken experimentally."[22] One way he recommended to achieve this was to rotate copper or zinc plates used in the intaglio method in order to discourage both chirality (right- or left-handedness) and conventional crosswise and up-down directedness. Pollock perhaps adopted this latter strategy for the central section of *Guardians of the Secret*. Hayter

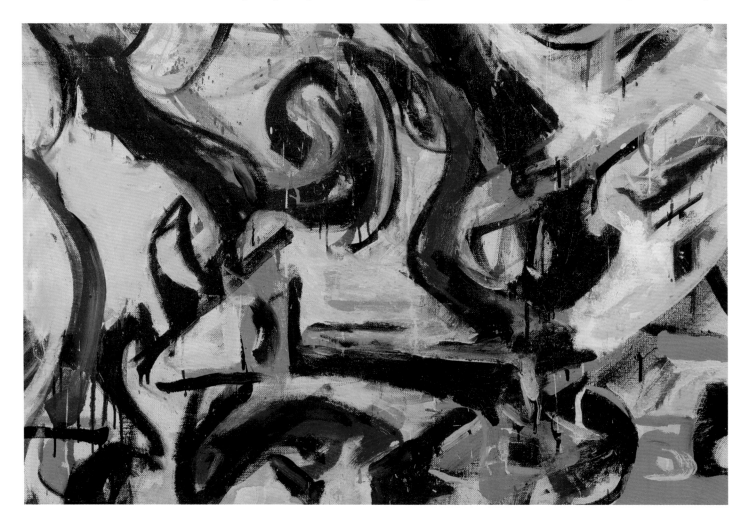

also advocated rapid execution (velocity), layering of imagery, encouraging accident, transposing figure and ground, counterposing texture to line, and (speaking metaphorically) "walk[ing] into your drawing like a map, instead of around it."[23] This he compared to the way prehistoric craftsmen had worked, a parallel likely appealing to Pollock's fascination with cave dwellers' art. Hayter's endorsement of alternating periods of contemplation with aggressive attack would, as Kadish pointed out, have reinforced Pollock's attraction to shamanistic practice and ritual.

Once the desired complexity for a given work was achieved, Hayter suggested filling in linear interstices and/or covering selected sections with opaque black to articulate structure; Pollock chose a dark green-blue for this purpose in punctuating *Mural*.[24] Indeed, with the exception of turning the canvas—due to its size and the space limitations of his Eighth Street studio, it had to remain upright and slanted (see fig. 21)—just about all of Hayter's recommended strategies are evident in *Mural*. The three successive snapshots taken of the painting before it was completed make this very clear (see fig. 27).[25] While *Mural*'s repetitive design of personages in movement spreads more or less evenly from edge to edge (see fig. 35b), conditions of erasure achieved through layering and the strategic allowance of palimpsests (imagery perceived beneath the surface) combine with articulated color correction to illuminate Pollock's visual thinking.

Especially evident is the fact that *Mural*'s radical size and the "trial" nature of its composition did not restrain Pollock from practices he would continue in the poured paintings, quick inspection at every stage and several "campaigns" of retouching (which would certainly not have been possible in one night). For example, in scattered areas throughout, a translucent casein-based white retail trade paint was added. This sits on top of and/or helps define forms originated with higher-quality oil pigment. As in the classic 1950 works—into which he really did step as he worked—even as he was making critical adjustments across *Mural*'s surface from both right to left and left to right, Pollock always kept in mind the marks being covered. The painting's final state appears more consciously strategic; in later examples concluding emendations would even come "down to the level of actually making a pouring seem to be above rather than below another for formal reasons."[26]

Already evident in *Mural* is Pollock's "absolutely distinctive" way (more distinctive than handwriting, according to Hayter) of diverting his art historical enthusiasms toward the fulfillment of personal needs.[27] Not surprisingly, given the young artist's great admiration for Picasso so brilliantly articulated by Rubin, there are noticeably *Guernica*-like echoes in significant areas of *Mural* (see, e.g., the upraised arm in the upper right corner of p. 98). In addition to his appreciation for Miró and Klee, the stimulus of Pollock's ongoing artistic colloquy with Matter factors into the radicality of this work. The year 1943 was a crucial one in their friendship, and letters prove that Pollock deeply missed Matter during the war years (1944–46), when he was away in California working for Charles and Ray Eames. Soon after Matter's return, in early 1947, Pollock asked to have pictures shot in front of Guggenheim's painting, in an area where both photographer and subject could step back and have more distance than her entry foyer, its original space. This

session, possibly scheduled in conjunction with *Mural*'s removal to the *Large-Scale Modern Paintings* exhibition opening in April at MoMA, took place in the studio of *Vogue* magazine, one of the Condé Nast publications Matter was staffing. Since its first reproduction, the better of these images has been integral to any conversation about this work.[28]

Matter's substantial role in introducing Pollock to the critic and MoMA curator James Johnson Sweeney and Sweeney's subsequent advocacy with Guggenheim have long been acknowledged, but evidence has also surfaced of artistic collaboration between the two friends.[29] Matter's "experimental" abstract photographs of the late 1930s to mid-1940s, especially those he exhibited at the Pierre Matisse Gallery in May 1943, would have provided additional examples close to home for Pollock's spontaneous energic approach, as well as his decisive turn away from a predetermined or discernible compositional focus. Both are signature aspects of his mature style that *Mural* prefigures.

Pollock certainly would have known Matter's electrical discharge emulsions and decentralized photograms from frequent visits to the Matters' Tudor City duplex during the year *Mural* was painted; their wives were very close at that time. In fact, Pollock began tentatively to try out dripping the same year Matter exhibited pictures of similarly generated ink-dropped-into-glycerine experiments (fig. 14); at least three smaller paintings featuring alloverness and conspicuous although more heavily applied pouring were included in November 1943 in Pollock's debut (fig. 15). He gave one of these to Herbert and Mercedes Matter as a retrospective wedding present. That Pollock abandoned dripping during Matter's absence in California and took it up again shortly after his late 1946 return may not be a total coincidence.

Perhaps more pertinent in comparison to *Mural*, where depicted action is enhanced through evidence of the act of its creation, are Matter's stroboscopic photographs of himself and others (including Mercedes and Krasner) walking, dancing, or otherwise seen in successive movement, and his participation in and design of the MoMA exhibition *Action Photography*, also in 1943. By using a strobe light, keeping the camera lens open, and allowing the strobe to fire continuously, each time recording a different view, Matter captured abstract and surrealistic effects simultaneously (fig. 16). Inspired by Harold Eugene Edgerton's multiflash experiments (demonstrated daily at MoMA's show), these striking motion photographs went well beyond the static repetitions of European photo pioneers; they also provided a more fluid compositional model (one incorporating energy diminishment from right to left) than Benton's diagram of curves looping around lateral poles (see fig. 18), often cited as a stimulus.[30] Pollock's attention to such photographic "action" effects is confirmed in a letter written to him by Guggenheim's assistant.[31] And incontrovertible evidence of Pollock's fascination with Matter's 1936 "chorus line" shots of undressed Shirley Temple dolls remained in the drawers of Pollock's East Hampton studio (fig. 17).[32]

What else can we find out or affirm about Pollock's inventive mind from deeper analysis of *Mural*'s "hinge" position at a transitional moment in his artistic trajectory? Francis O'Connor's observation that "Pollock's work builds up an archeology of facture that he always reveals"

is recognizably present. While remnants of lower strata are sometimes visible in *Mural*, Pollock's extremely varied repertoire of strokes is unambiguously evident on all stratigraphic planes. These strokes, as Matthew Rohn has explained, can range from thin and linear, dotlike, pooled or patchy, delicate and feathery, to heavily encrusted.[33] Retaining their exploratory feeling, such combinations resolve nevertheless in a painterly way.

In reference to Pollock's greater assurance by the time his allover paintings began, Krasner was once asked, "How did this confidence evolve? Was it an outcome of all the years of drawing and the translation of that drawing into a larger gesture?" She responded in the affirmative, recalling that her husband's backlog of drawings amounted to "quite a body of work." "At some point," she stated, "he was ready to let it all happen in the scale he wanted it to happen on."[34] Albeit an early attempt, *Mural* indicates Pollock's growing consciousness of "what came before" in his own

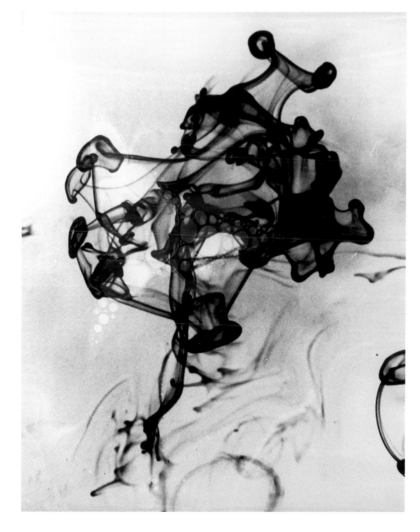

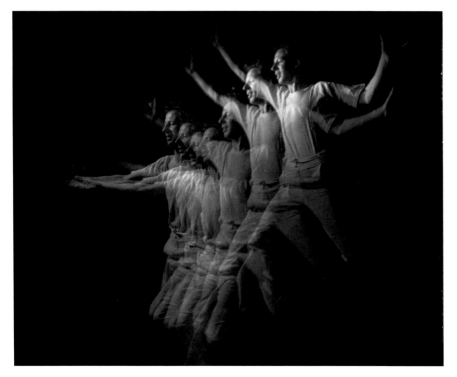

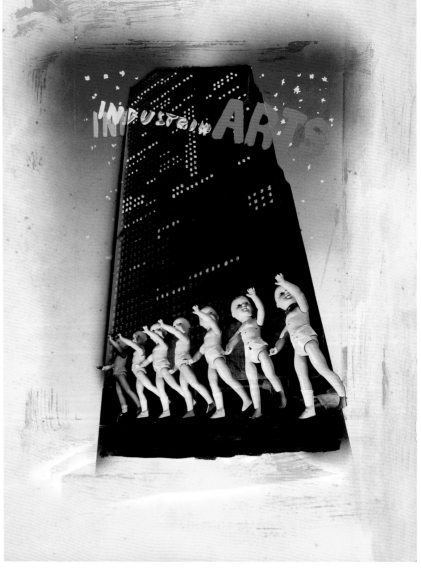

FIGURE 16
Herbert Matter, *Self-Portrait in Motion*, 1942.
Silver gelatin print, 20 × 25.4 cm (7⅞ × 10 in.).
Palo Alto, CA, Stanford University Libraries,
Department of Special Collections and University
Archives

FIGURE 17
Herbert Matter, *Industrial Arts Poster*, 1936.
Mixed-media collage, photo collage, and
tempera on illustration board, 44.8 × 33.7 cm
(17⅝ × 13¼ in.). East Hampton, NY, Pollock-
Krasner House and Study Center

FIGURE 18
Thomas Hart Benton, illustrations from "The
Mechanics of Form Organization in Painting,"
Arts 10, no. 5, November 1926, redrawn from
pencil sketches by Lloyd Goodrich (American,
1897–1987)

production with the same acute understanding of potentialities applied to other artists of interest. Recent examination of Pollock's facture using hyperspectral data imaging and other advanced conservation techniques reaffirms the consistency of his intratextual practice. Microscopic examination of the highly original "technics" he developed to satisfy his own complicated psychological and aesthetic drives underscores Pollock's constant "consciousness of the old" even as he moved in newer, more exciting directions.

The "Action Painting" critic Harold Rosenberg (Greenberg's rival) once described Pollock's temporally implicated mode of creativity as visually equivalent to a play on words. Looking at a mature work by Pollock, Rosenberg marveled at how "sheer sensuous revels in paint" could all at once "transform themselves into visionary landscapes" and reconfigure back into "contentless agitations of materials."[35] In 1947 Rosenberg and Motherwell asked Pollock to contribute a statement for their first (and only) edited issue of a magazine they called *Possibilities*. "I have no fears about making changes, destroying the image, etc.," Pollock declared; his paintings, he explained, had "a life" of their own. "I try," he added, "to let it come through."[36]

One of Rubin's apparent aims in writing "Jackson Pollock and the Modern Tradition" was to counter the charge (still sometimes aired) that Pollock's poured works are either simply decorative or else chaotic and meaningless; critical comparisons in the late 1940s ranged from "wallpaper patterns" and "a most enchanting printed silk" to "a child's contour map of Gettysburg," "a mop of tangled hair," and "baked macaroni." Despite *Mural*'s destiny as a foyer adornment (fig. 19), Pollock already had a very different goal in creating it, one that would be elaborated considerably in his signature paintings. "Mere decoration," Rubin argued, "is definable as the formulaic repetition (hence predictability) of impersonal marks in absolute symmetry on a field of potentially indefinite extension. Pollock's art, contrarily, involves a mosaic of esthetic decisions in a context of free choice over a field whose exact shape and size plays a crucial part. The precarious poise of

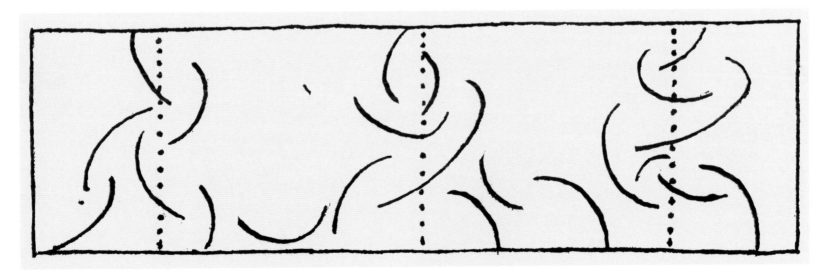

FIGURE 19
George Karger (German, 1902–1973), Peggy
Guggenheim and Jackson Pollock in front of
Mural (1943), first floor entrance hall,
155 East Sixty-First Street, New York, ca. 1946.
Solomon R. Guggenheim Foundation

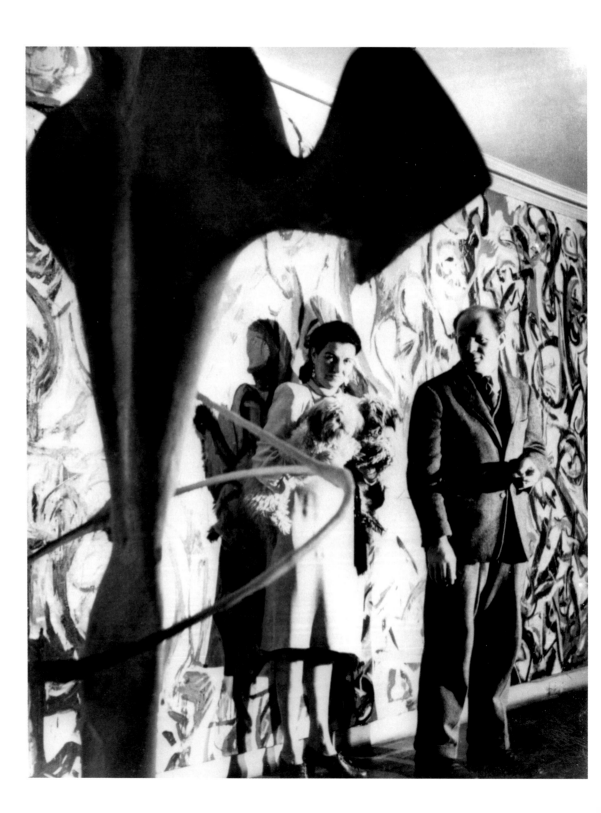

his all-over, single image is achieved through the equally precarious balancing of virtually endless asymmetries."[37]

While not quite there yet, *Mural*'s precocity proved vitally important for American modernism in the mid-twentieth century. It is distinctly impossible to substitute the name of any other painter at work in this country, including those also privy to similar wartime sources in New York, who found an equivalent way to revolutionize aesthetic expression as early as 1943. We are still learning from Pollock exactly what it takes to both envision and embody art's potentiality.

NOTES

1. Author's conversation with Ed Harris, East Hampton, NY, July 22, 1998. Scenes from *Pollock*, a film by Ed Harris, Brant-Allen Films/Columbia TriStar Home Entertainment, 2000.

2. Clement Greenberg, "Art," *The Nation* 160 (April 7, 1945): 397; "Art," *The Nation* 157 (November 27, 1943): 621; "The Present Prospects of American Painting and Sculpture," *Horizon* 93 (October 1947): 25–26.

3. Maude Riley, "Fifty-Seventh Street in Review: Explosive First Show," *Art Digest* 18 (November 15, 1943): 18. Robert M. Coates, *New Yorker*, November 20, 1943, 97–98; May 29, 1943, 49.

4. Hayter comparison: J[ames] R L[ane], "Review of American and French Painting, McMillen Inc.," *Art News* 40 (January 15–31, 1942): 29. Coates's comment: *New Yorker*, January 17, 1948, 56–57.

5. Holograph statement reproduced in Francis V. O'Connor and Eugene Victor Thaw, eds., *Jackson Pollock: A Catalogue Raisonné of Paintings, Drawings, and Other Works*, 4 vols. (New Haven: Yale University Press, 1978), vol. 4, 253.

6. Frank O'Hara, *Jackson Pollock* (New York: George Braziller, 1959), 22, 26. Clement Greenberg, "Art," *The Nation* 162 (April 13, 1946): 444–45.

7. B[elle] K[rasne], "Fifty-Seventh Street in Review: Jackson Pollock," *Art Digest* 25 (December 1, 1950): 16. Applying for a John Simon Guggenheim Foundation grant in 1947, Pollock wrote (probably with Greenberg's help):

> I intend to paint large movable pictures which will function between the easel and mural. I have set a precedent in this genre in a large painting for Miss Peggy Guggenheim which was installed in her house and was later shown in the "Large-Scale Paintings" show at the Museum of Modern Art. It is at present on loan at Yale University.
>
> I believe the easel picture to be a dying form, and the tendency of modern feeling is towards the wall picture or mural. I believe the time is not yet ripe for a *full* transition from easel to mural. The pictures I contemplate painting would constitute a halfway state, and an attempt to point out the direction of the future, without arriving there completely. (O'Connor and Thaw, *Jackson Pollock: A Catalogue Raisonné*, vol. 4, 238; original emphasis.)

8. O'Hara, *Jackson Pollock*, 28.

9. Victoria Newhouse, *Art and the Power of Placement* (New York: Monacelli Press, 2005), 196–209. "Zone of vision": journal notation, October 23, 1970, Clement Greenberg Papers, Getty Research Institute, Special Collections and Visual Resources.

10. "[Allover works on account it means] no limits, just edges": Pollock, quoted in Helen Harrison, ed., *Such Desperate Joy: Imagining Jackson Pollock* (New York: Thunder's Mouth Press, 2000), 93. Stephen Foster cites *Mural* as an "initial statement" and Pollock's *Number 27, 1950* as a "nearly definitive solution" to the problem of reducing figuration to "traces of the painter's passage through the painting." "Turning Points in Pollock's Early Imagery," *University of Iowa Museum of Art Bulletin* (Iowa City) 1, no. 1 (Spring 1976): 34.

11. William Rubin, "Jackson Pollock and the Modern Tradition," *Artforum* 5, nos. 6–9 (February–May 1967); reprinted in Pepe Karmel, ed., *Jackson Pollock: Interviews, Articles, and Reviews* (New York: Museum of Modern Art, 1999), 118–75. *Bricolage* is the creation of structures by means of the "already used."

12. Jackson Pollock, "Interview with William Wright," The Springs, 1950, radio station WERI, Westerly, RI, 1951; reprinted in Karmel, *Interviews*, 22. Shortly before his death in 1956, Pollock disavowed complete abstraction: "I don't care for 'abstract expressionism'…and it's certainly not 'nonobjective,' and not 'nonrepresentational' either. I'm very representational some of the time, and a little all of the time." Quoted in Selden Rodman, *Conversations with Artists* (New York: Devin-Adair, 1957), 82.

13. O'Connor and Thaw, *Jackson Pollock: A Catalogue Raisonné,* vol. 4, 253; original emphasis.

14. Influence of Siqueiros and Matta: Ellen G. Landau, *Jackson Pollock* (New York: Harry N. Abrams, 1989) and *Mexico and American Modernism* (New Haven: Yale University Press, 2013).

15. Bernice Rose, *Jackson Pollock: Drawing into Painting*, International Council of the Museum of Modern Art, New York (Oxford: Museum of Modern Art, Oxford, and the Arts Council of Great Britain, 1979), 14–21.

16. T. J. Clark, "Pollock's Smallness," in *Jackson Pollock: New Approaches,* ed. Kirk Varnedoe and Pepe Karmel (New York: Museum of Modern Art, 1999), 21. Piri Halasz, "Stanley William Hayter: Pollock's Other Master," *Arts Magazine* 59 (November 1984): 73–75.

17. James Johnson Sweeney, "New Directions in Gravure: Hayter and Studio 17," *Bulletin of the Museum of Modern Art* 12 (August 1944): 3.

18. Hayter: Halasz, "Stanley William Hayter," 75. Kadish: Reba Williams and Dave Williams, "The Prints of Jackson Pollock," *Print Quarterly* 5, no. 4 (1988): 354.

19. Hayter's claim that he originated the oscillation technique and that Ernst's experiments took place at Atelier 17: Jeffrey Potter, audiotaped interview, East Hampton, NY, June 11, 1983, Pollock-Krasner House and Study Center.

20. Stanley William Hayter, "Paul Klee: Apostle of Empathy," *Magazine of Art* 39, no. 4 (April 1946): 129. Manny Farber, "Jackson Pollock," *New Republic*, June 25, 1945, 871–72, termed three Pollock paintings "masterful and miraculous," one of them "a wild abstraction twenty-six feet long, commissioned by Miss Peggy Guggenheim for the hallway of her home": "The mural is . . . an almost incredible success. It is violent in its expression, endlessly fascinating in detail, without superficiality, so well ordered that it composes the wall in a quiet, contained, buoyant way. . . . The mode is . . . one that stems from Miró and Picasso but is a step further in abstraction. The style is personal and, unlike that of many painters of this period, the individuality is in the way the medium is used rather than in the peculiarities of subject matter."

21. Steven Naifeh and Gregory White Smith, *Jackson Pollock: An American Saga* (New York: Clarkson N. Potter, 1989), 468; Henry Adams, *Tom and Jack: The Intertwined Lives of Thomas Hart Benton and Jackson Pollock* (New York: Bloomsbury Press, 2009), 274–75. Naifeh and Smith embroider considerably Krasner's assertion that *Mural* was painted in one sitting in late December 1943 (told by her to this author as well and confirmed by John Little, July 1979). In a letter of November 25, 1965, to Francis V. O'Connor, the painter Harry Jackson states Pollock said "he had tried to paint a horse stampede on it and when it got beyond his control he got mad and started to sling the paint onto the canvas to create the driving, swirling action and thrust the composition and the heroic size demanded." Naifeh and Smith assert the horses were joined "by every animal in the American West," then covered up, a fact not supported by hyperspectral imaging. Based on analysis by the conservator Carol C. Mancusi-Ungaro, writing in "Jackson Pollock: Response as Dialogue," in Varnedoe and Karmel, *New Approaches*, 117–19, and O'Connor's essay, "Jackson Pollock's *Mural* for Peggy Guggenheim: Its Legend, Documentation, and Redefinition of Wall Painting," in *Peggy Guggenheim and Frederick Kiesler: The Story of Art of This Century*, ed. Susan Davidson and Philip Rylands (New York: Guggenheim Museum Publications, 2004), 150–69, Adams refutes the one-night genesis of *Mural*. He does discern horse heads, as well as the artist's first and last name writ large across the canvas (see www.smithsonianmag.com/arts-culture/Decoding-Jackson-Pollock .html). Harry Jackson's reminiscence to Jeffrey Potter is perhaps more to the point: "[Pollock] told me that he started dripping paint because he became so excited while painting the mural for Peggy Guggenheim, that he lost hope of keeping up with his excitement using a brush." Quoted in Potter, *To a Violent Grave: An Oral Biography of Jackson Pollock* (New York: G. P. Putnam's Sons, 1985), 98.

22. Stanley William Hayter, *New Ways of Gravure* (New York: Pantheon, 1949), 219.

23. "Like a map": quoted in Michael Brenson, "Stanley William Hayter, 86, Dies; Painter Taught Miro and Pollack [*sic*]," *New York Times,* May 6, 1988, 28.

24. Mancusi-Ungaro, "Jackson Pollock: Response as Dialogue," 118–19, analyzes Pollock's 1943 practice of deliberately filling in negative spaces with neutral gray paint, a process she calls "masking." Employing "focused meticulous reengagement" (Varnedoe and Karmel, *New Approaches*, 100), Pollock used gray-green paint for this purpose in *Mural*.

25. See discussion elsewhere in this volume that explores in further detail what these three snapshots reveal about Pollock's retouching of *Mural*.

26. James Coddington, "No Chaos Damn It," in Varnedoe and Karmel, *New Approaches*, 102; O'Connor, "Jackson Pollock's *Mural*," 156.

27. Potter, *To a Violent Grave*, 98.

28. O'Connor, in "Jackson Pollock's *Mural*," 159, captions this photo as taken either at Vogue Studio or at Studio Associates, New York City, ca. 1946 (he favors the former hypothesis in n. 36, 167). Matter did not return from California until the

very last days of 1946 and was not affiliated with Studio Associates until 1950. Around 1948–49 Pollock sent at least one other work to Vogue Studio to "see it in an enormous space." First reproduction: B. H. Friedman, *Jackson Pollock: Energy Made Visible* (New York: McGraw-Hill, 1972).

29. See Ellen G. Landau, "Action/Re-Action: The Artistic Friendship of Herbert Matter and Jackson Pollock," in *Pollock Matters*, ed. Ellen G. Landau and Claude Cernuschi (Boston: McMullen Museum of Art, 2007), 9–58.

30. Stephen Polcari, in "Jackson Pollock and Thomas Hart Benton," *Arts Magazine* 53 (March 1979): 120–24, argues that *Mural*, as well as other works, including *Composition with Figures and Banners*, ca. 1934–38 (fig. 2), and *Blue Poles: Number 11, 1952*, was based on Benton's prime organizational strategy: vertical poles extending laterally across a canvas or wall, with curvilinear rhythmic sequences disposed around each (see fig. 18). Harry Jackson also presented Benton's achievements as fundamental:

> [Pollock] talked to me a great deal about that canvas for the hallway. He regretted that he was unable to make it a great figurative mural but he felt that the disciplines necessary for realizing such a work had been lost to us. He admired Tom Benton and he wanted to be able to do what Tom dreamed of doing, that is, to make Great and Heroic paintings for America. He was painfully aware of not being able to do it the way he wished and he was determined to do it the way he could.

> Harry Jackson, quoted in O'Connor, "Jackson Pollock's *Mural*," 161.

31. Undated letter from Howard Putzel to "Lee and Pollock" on Art of This Century stationery (therefore 1942–44), Jackson Pollock and Lee Krasner Papers, Archives of American Art, Smithsonian Institution, accessed October 19, 2013, at www.aaa.si.edu/collections/container/viewer/Putzel-Howard-Art-of-this-Century-285958. A half-page story on Marcel Duchamp from *Cue* magazine "appropos [sic] the stroboscopic photo of a nude descending a stairs" is discussed.

32. Landau, "Action/Re-Action," 21, 46 nn. 46, 49.

33. Francis V. O'Connor, "Jackson Pollock: Down to the Weave," in Harrison, *Such Desperate Joy*, 179. Matthew L. Rohn, *Visual Dynamics in Jackson Pollock's Abstractions* (Ann Arbor, MI: UMI Research Press, 1987).

34. Barbara Rose, "Jackson Pollock at Work: An Interview with Lee Krasner," *Partisan Review* 47, no. 1 (1980): 82–92; reprinted in Karmel, *Interviews,* 45.

35. Harold Rosenberg, "The Art World: The Mythic Act," *New Yorker*, May 6, 1967, 162–71. See also Rosenberg's "The American Action Painters," *Art News* 51 (December 1952): 22–23, 48–50.

36. Jackson Pollock, "My Painting," *Possibilities* 1 (Winter 1947–48): 83.

37. William Rubin, "Jackson Pollock and the Modern Tradition: Part II: The All-Over Composition and the So-Called Drip Technique" (March 1967); reprinted in Karmel, *Interviews,* 131.

JACKSON POLLOCK'S *MURAL*: MYTH AND SUBSTANCE

YVONNE SZAFRAN, LAURA RIVERS, ALAN PHENIX, AND TOM LEARNER

A key figure in the evolution of twentieth-century American painting, Jackson Pollock created dynamic and complex works that continue to captivate and challenge those who study them. This is attributable in part to his experimental approach to the handling of paint, which eventually grew into the style for which he is most well known, his drip paintings. Pollock's earlier paintings have been less studied than the later, more iconic ones, however, and the investigation of *Mural* (1943) has provided insights into the development of his working methods. This present study of *Mural* has been enriched by the generosity of colleagues who have shared ongoing research, as comparison with other works by the artist has been central to forming a more comprehensive understanding of a work that has been described as "twentieth-century America's first influential large-scale easel painting."[1]

Pollock is an artist whose life and work have engendered a rich mythology, an intricate mixture of legend and fact that fascinates the general public and the scholarly community alike. Perhaps the earliest instances of this phenomenon are the stories about *Mural* that surfaced almost immediately upon its creation—and that continue, even today, to surround the painting. From the moment of Peggy Guggenheim's commission of perhaps the largest work Pollock ever painted,[2] *Mural* has been the subject of rumor, speculation, and hearsay. Almost as soon as it was painted, it took on its role as a key point in his artistic evolution, the beginning of his upward trajectory to his status as one of the most important American painters of the twentieth century.

The installation of the painting in Guggenheim's New York townhouse generated tales with great inconsistencies. The Pollock scholar Francis O'Connor has confronted and resolved much of the mythology attached to *Mural*,[3] but questions still remain, and this essay attempts to clarify some of them.

FIGURE 20
Arrival and unpacking of *Mural* in July 2012
at the J. Paul Getty Museum.

How long did it take Pollock to paint *Mural*? What kinds of paints did he use, and how did he apply paint to canvas? These are questions that have prompted much discussion since the painting's creation, and the many documentary sources unfortunately are often contradictory. This essay delves into the creation of the painting, from its commission to the materials and techniques Pollock used to make it, addressing also the changes the painting underwent over the course of time as a result of many factors, including its move from its original location and earlier conservation treatments.

The most recent treatment and technical study of *Mural*, undertaken at the Getty beginning in July 2012, provided a valuable opportunity to look closely at the painting's material structure, exploring in depth the kind of paints Pollock used and how they were applied (fig. 20). In addition to conventional methods of paint analysis, some of the latest developments in technical imaging were employed to obtain a better understanding of the order, distribution, and method of application of the various layers of paint. (Details of these scientific methods are provided in the appendix.) The technical study produced a wealth of information, revealing an artist who combined traditional materials and methods of application with more unconventional ones. One compelling discovery is that Pollock adopted an unusual combination of paint types in *Mural*; this innovation, along with his creative and dynamic methods of paint application, foreshadows the better-known working methods that became his defining approach only a few years after this work was completed.

Knowledge of the material structure of the painting and its condition informed our understanding of certain physical changes that have taken place over the course of the painting's history, changes that have had a profound impact on the painting's appearance today. Study of the painting also elucidated structural changes that the painting has undergone over the seventy years since its creation. These new findings on the material and structural state of the painting contributed to the decisions made during the course of the Getty's conservation treatment. A discussion of some of the challenges we faced during the treatment of this extraordinary painting will follow.

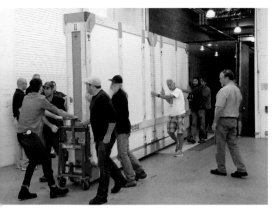
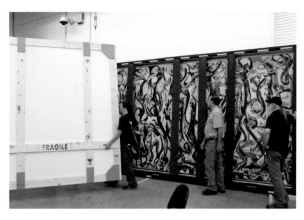
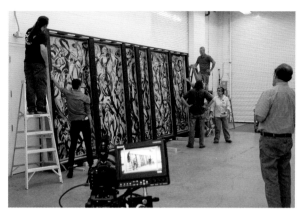
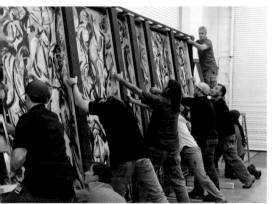
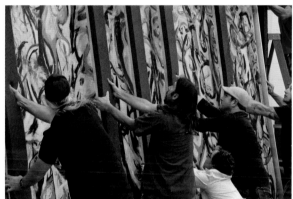
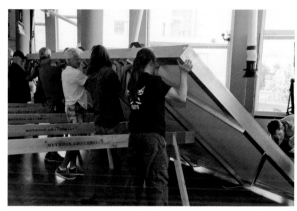
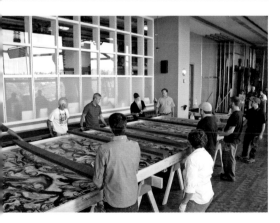
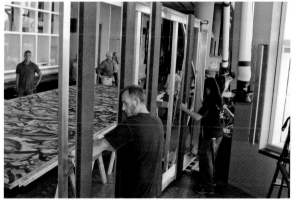
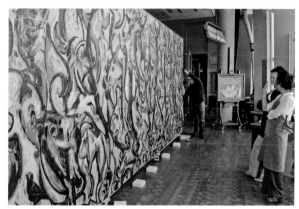

THE COMMISSION

The earliest mention of *Mural* by Pollock himself is in a brief postcard he wrote to Lee Krasner on July 15, 1943: "Have signed the contract and have seen the wall space for the mural—it's all very exciting."[4] In addition to commissioning the mural for her duplex townhouse, Guggenheim's somewhat unusual one-year contract—a major breakthrough in the artist's career—ensured Pollock a monthly stipend of $150 (an advance against the future sale of $2,700 in paintings) and his first one-man show.[5]

Two weeks later, on July 29, Pollock wrote to his brother Charles, describing the arrangement in more detail and referring to the exhibition and the mural commission that were part of the patronage agreement: "I have a year's contract with (the art of the Century [*sic*]) and a large painting to do for Peggy Guggenheim's house, 8' 11½" × 19' 9" with no strings as to what or how I paint it. I am going to paint it in oil, on canvas. They are giving me a show November 16, and I want to have the painting finished for the show. I've had to tear out the partition between the front and middle room to get the damned thing up. I have it stretched now. It looks pretty big, but exciting as all hell."[6] It was the largest painting Pollock had tackled up to that point, and the monumental undertaking was significant enough to merit a photograph of the artist standing in front of the unpainted canvas in his Eighth Street studio (fig. 21).

Krasner later related: "Peggy Guggenheim commissioned the mural for her apartment, which is the largest painting Pollock ever painted. That was in 1943. Incidentally, that's not painted on the floor.... For that mural, we had to rip out a wall and carry out the plaster in buckets every night.... [W]e needed to create a wall large enough to hold the mural, so we broke down a partition between two rooms. That created a wall long enough for him to get that big mural painting on."[7]

The great scale of the painting allowed Pollock to take his practice beyond the confines of the smaller canvases he had previously produced and to move toward the experimental application and manipulation of paint that would become the hallmark of his painting technique. It also allowed him to take on what he perhaps considered the most worthy of artistic challenges: the painting of a mural. One could argue that Pollock's development toward innovative and nontraditional paint application was encouraged and facilitated by this opportunity to work on such a large scale, the great expanse of canvas inviting large gestures such as throwing or spattering the paint rather than brushing or dabbing it.

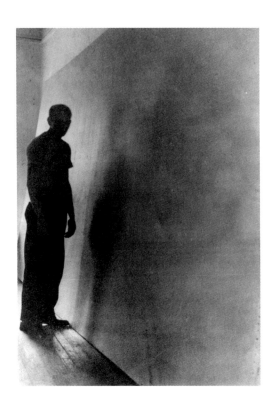

THE PAINTING PROCESS: DURATION

The question of how long it took Pollock to paint *Mural* has been one of the most intriguing of the uncertainties about the work.[8] On January 15, 1944, Pollock sent a letter to his brother Frank in which he clearly states when he painted *Mural*. He writes, "I painted quite a large painting for Miss Guggenheim's house during the summer—8 feet × 20 feet. It was grand fun."[9]

A letter postmarked November 12, 1943, on Art of This Century letterhead, from Guggenheim to her friend Emily [Mimi] Coleman Scarborough, supports the understanding that the painting was finished by early November. Guggenheim writes: "We had a party for the new genius Jackson Pollock; [*sic*] who is having a show here now. He painted a 20 foot mural in my house in the entrance. Everyone likes it nearly except Kenneth [Macpherson]."[10] However, Krasner apparently recalled on more than one occasion that Pollock painted the work in one day or less, and this tale has been repeated in the scholarly literature as well as in the popular portrayal of Pollock.[11] Guggenheim relates similar descriptions of an extremely fast execution in her autobiographies, although there is some variation over the years.[12]

Careful observation of the painting itself suggests that such ambitious and rapid work is not the case here, as there are many areas of dried oil paint evident under subsequent layers of paint.[13] Scientific analyses of minute samples of paint confirm this.

THE PAINTING PROCESS: MATERIALS AND TECHNIQUE

THE SUPPORT

A good-quality piece of artists' canvas sufficiently large to carry out this mural commission might have been difficult to obtain in the midst of World War II, and apparently Guggenheim acquired the canvas on Pollock's behalf.[14] Advertisements in *Art Digest,* a magazine for artists published throughout the war years and beyond, indicate that "Belgian linen" was readily available in a number of art supply stores in New York in 1943. These stores must have had existing stock, as it is unlikely that such material could have been easily exported from Belgium in wartime.

The canvas is self-evidently one very large piece of a commercially prepared product: Pollock's paint is essentially restricted to the picture area and does not extend significantly onto the tacking margin, save for a few drips mainly on the bottom edge. The white priming on the canvas extends across the unpainted tacking margins, to the cut edges of the fabric on both the vertical and horizontal sides. Although no selvedges are present that would reveal the loom directions, it is reasonable to conclude that the horizontal direction corresponds to the warp (machine direction) threads and that the vertical threads are the weft (cross direction), as might be expected for a canvas of this size and shape. The canvas has a distinct type of weave: a three-over-two basket weave; the horizontal (warp) threads are actually a bundle of three yarns side by side through which a

bundle of two side-by-side weft yarns are interwoven in simple alternate fashion. The result is a canvas with a pronounced but fairly flat surface texture that derives from the small, rectangular "tiles" created where the three bundled warp yarns overlay the bundle of two wefts.[15] This is easily discernible upon close examination (fig. 22).

The priming on the canvas is a double ground consisting of an initial layer of zinc white followed by a thin layer of lead white, both seemingly in oil (figs. 23a–b).[16] The white priming remains visible in many places across the painting, especially toward the top edge, where it provides the light background "reserves" between many of the painted colored shapes (fig. 24).

According to Pollock's letter of July 29, 1943, to his brother Charles, he stretched the canvas himself. Uncropped versions of the photograph of Pollock before the unpainted canvas show in the bottom right corner the original tacks that held the canvas on the stretcher (see fig. 21). Little evidence remains, however, regarding the construction of the original stretcher, which was replaced at some point in the past.[17] An image taken in early 1947 by Herbert Matter at Vogue Studio, probably as the painting moved from Guggenheim's townhouse to the Museum of Modern Art (MoMA) for the *Large-Scale Modern Paintings* exhibition, gives us information about the original stretcher (fig. 25). In the image, a formal portrait of Pollock before the painting, the stretcher bars can be seen serving as a temporary frame, placed directly on top of the painted surface.[18]

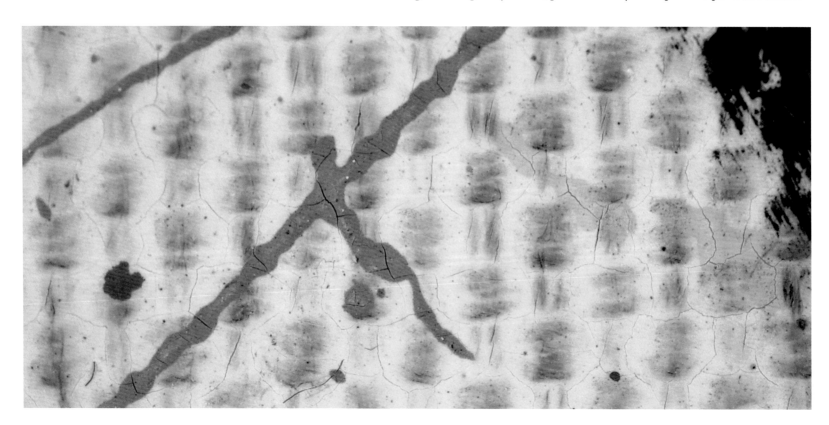

FIGURE 23A

Cross section from an area of pale warm yellow over pink, center left. Layers **2** and **3** correspond to the double priming of lead white over zinc white.

7 Varnish (not original)
6 Pale warm yellow paint: titanium white, zinc white, and cadmium yellow
5 Retail trade paint: lithopone and silicates
4 Opaque pink paint: titanium white, zinc white, and alizarin crimson
3 Upper lead white priming
2 Lower zinc white priming
1 Canvas sizing

FIGURE 23B

Cross section shown in figure 23a viewed by ultraviolet fluorescence.

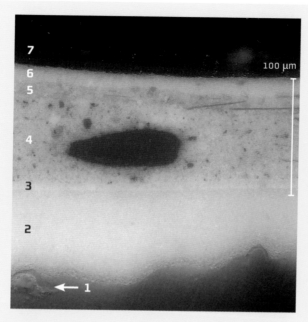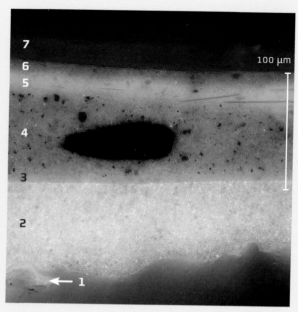

FIGURE 24

Detail of *Mural* (top center) showing areas of white priming between the gray-green, brown, yellow, and pink brushstrokes.

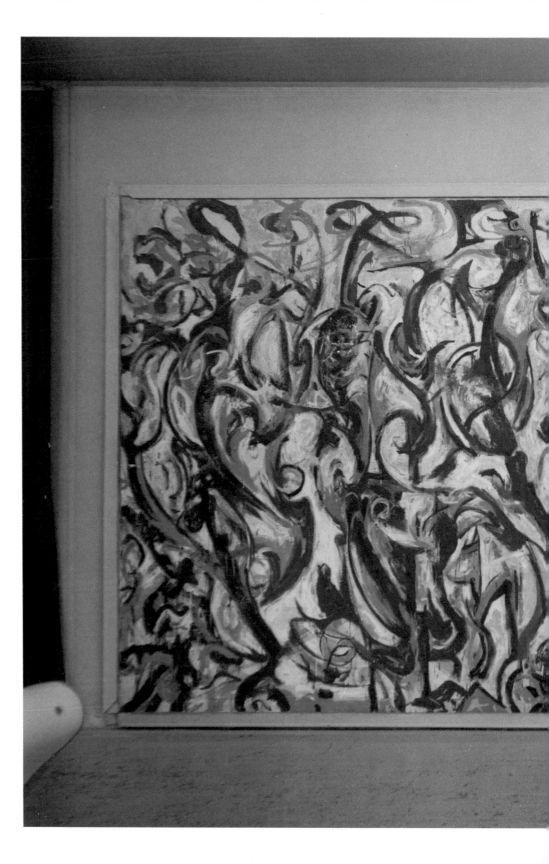

FIGURE 25

Herbert Matter, Jackson Pollock with *Mural*, 1947. Palo Alto, CA, Stanford University Libraries, Department of Special Collections and University Archives

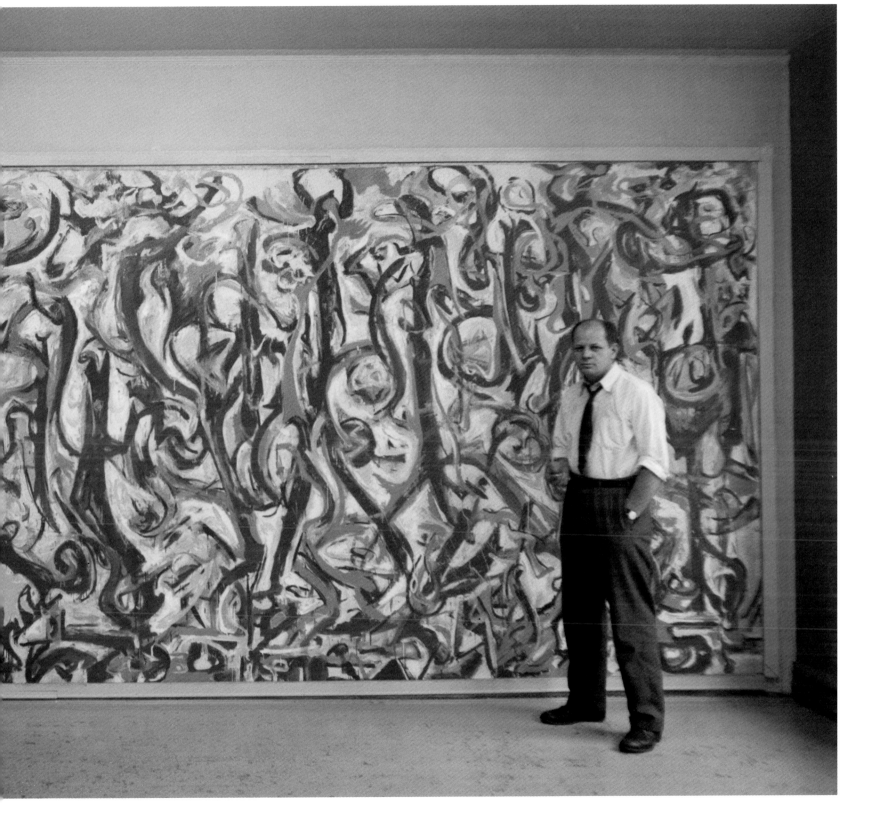

Herbert Matter, Jackson Pollock with *Mural*, 1947. Palo Alto, CA, Stanford University Libraries, Department of Special Collections and University Archives

This (uncropped) image from the same photo session as figure 25 was once thought to have been taken at the Art of This Century gallery. However, some features of this room suggest that the photos may have been taken at Vogue Studio in early 1947.

Detail of figure 26a showing that the "frame" is actually the original stretcher.

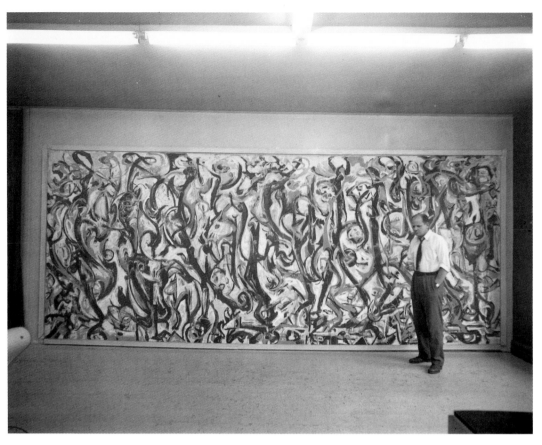

FIGURE 27

Unknown photographer, sectional views of Jackson Pollock's *Mural* in his Eighth Street apartment, 1943. East Hampton, NY, Pollock-Krasner House and Study Center

Viewed together, these sectional photographs of *Mural* show most of the painting in a late, incomplete stage. (The small size of Pollock's apartment would have made it impossible to photograph the entire painting in one frame.)

The painting (no doubt rolled and unstretched at this point, for ease of transportation) was simply tacked to the wall for the purpose of the photo shoot. Only the peripheral stretcher bars are shown, their mitered corners visible at the four corners of the painting. Closer examination reveals a small square of canvas visible where the stretcher bars meet, as well as a join at the center of each of the horizontal stretcher bars (figs. 26a–b). Also visible, on the floor at the left, is a long cylindrical object, possibly the tube on which the painting had been rolled for transport. Large paintings are often taken off their stretchers and the painted canvas rolled during transportation or storage. This must have been the case with *Mural* through much of its early life.

There are indications that the stretcher was, from the very beginning, not sturdy enough to support the heavy canvas. An early series of photographs of the painting in process, as well as the photograph of Pollock in front of the unpainted canvas, suggest that the top may have begun to sag even as it was being painted, a problem compounded by the weight of the paint layers but probably due mainly to a stretcher not sufficiently robust for the great size of the work (fig. 27). Pollock must have been aware of this problem, but given the painting's large scale, this issue may have seemed visually insignificant, a minor concern when compared to the artistic challenges of such a big and important commission. Furthermore, Pollock may have expected to address the issue during the installation.

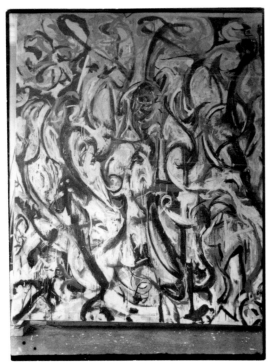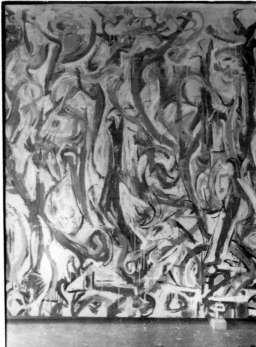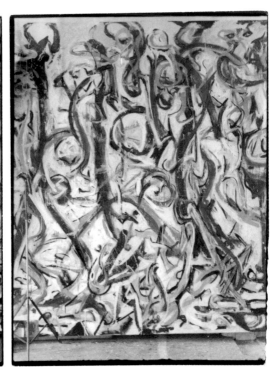

FIGURE 28

Detail of *Mural* (middle left) showing intense red, orange, and yellow splatters intermingled with brushstrokes in the same colors.

THE TECHNIQUE

The painting is a complex and intricate composite of brushstrokes, splatters, smears, and dabs. A multitude of colors weaves across the canvas, and it is difficult to establish the exact order of application, as the same colors were used from start to finish, many of them appearing in both the early and late stages of painting. The combination of quickly applied but controlled brushed paint (applied with brushes of varying sizes) and more "accidental" thrown paint results in wonderful graphic and painterly effects. Colors of varying intensity and texture and paint of different consistencies were applied across the great canvas with an energy that is evident in the effects that have been achieved. Intense red, orange, and yellow splatters (fig. 28) intermingle with brushed applications of the same colors, along with vibrant greens, brilliant blues, and a generous use of pink, the whole of the canvas unified with white and broad strokes of gray-green (fig. 29). The white areas are varied: some are merely the unpainted ground layers, some are washy and translucent, while others are bright, opaque, and pastose, late additions to the

FIGURE 29
Detail of *Mural* (lower right) with unifying strokes of white and gray-green.

complex arrangement (fig. 30). Broadly brushed calligraphic lines of dark brown anchor the composition. Drips of thick paint are visible both as final layers and underneath other layers. Some of the earliest strokes appear to have been extremely thin and fluid, with drips flowing to the bottom edge of the canvas (fig. 31). While there are passages that were clearly painted wet into wet, with different colors bleeding and swirling into each other (fig. 32), other areas demonstrate a well-defined and progressive layering of colors, their distinct separations indicating that one layer was dry before the next was applied (fig. 33). One of the last paint applications is perhaps one of the most intriguing, providing the closest link to the drip technique that the artist would turn to beginning in 1947. Skeins of delicate pale pink fall across the surface (fig. 34), exhibiting the variation of line and unique visual energy of thrown paint, the technique that would come to dominate Pollock's later paintings.

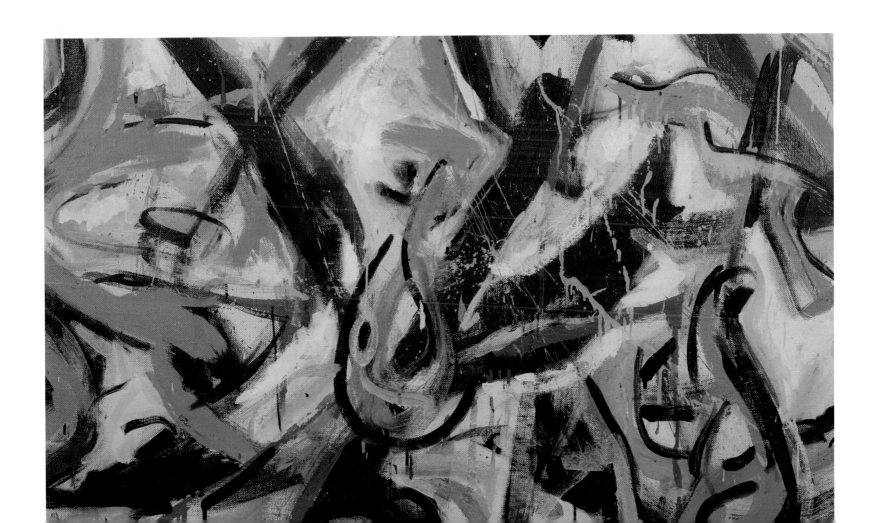

FIGURE 30
Detail of *Mural* (lower mid-left) including three whites: unpainted ground in the upper left corner, a swirl of translucent white in the center, and an area of pastose white in the lower right.

FIGURE 31
Detail of *Mural* (lower right corner) showing drips of early applications of paint flowing onto the bottom edge of the canvas. (The original tacking margin is visible on the face of the painting in this pretreatment photograph.)

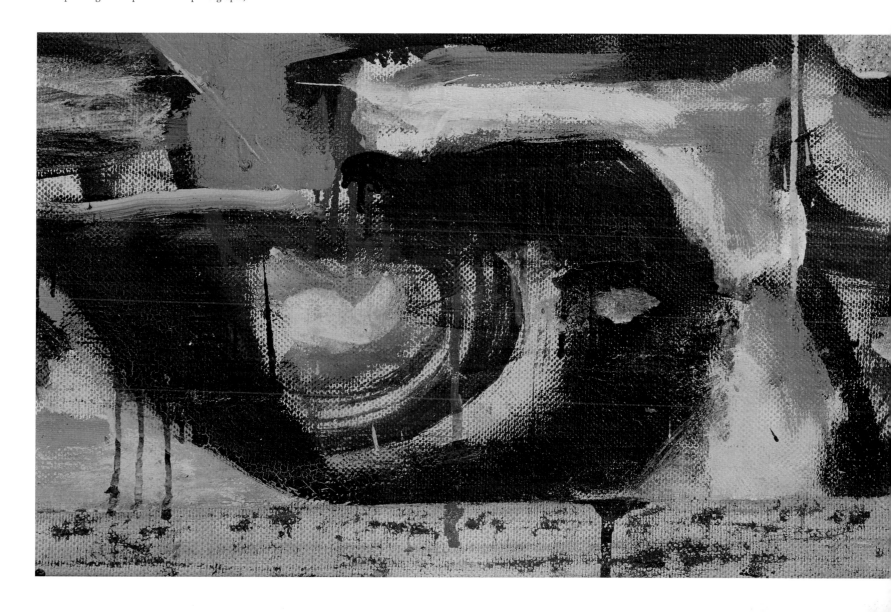

FIGURE 32

Detail of *Mural* (top center) with passages clearly painted
wet into wet, with colors swirling into each other.

FIGURE 33

Detail of *Mural* (center) demonstrating a well-defined and
progressive layering of colors. The light yellow brushstrokes
were dry prior to the application of the darker blue and pink.

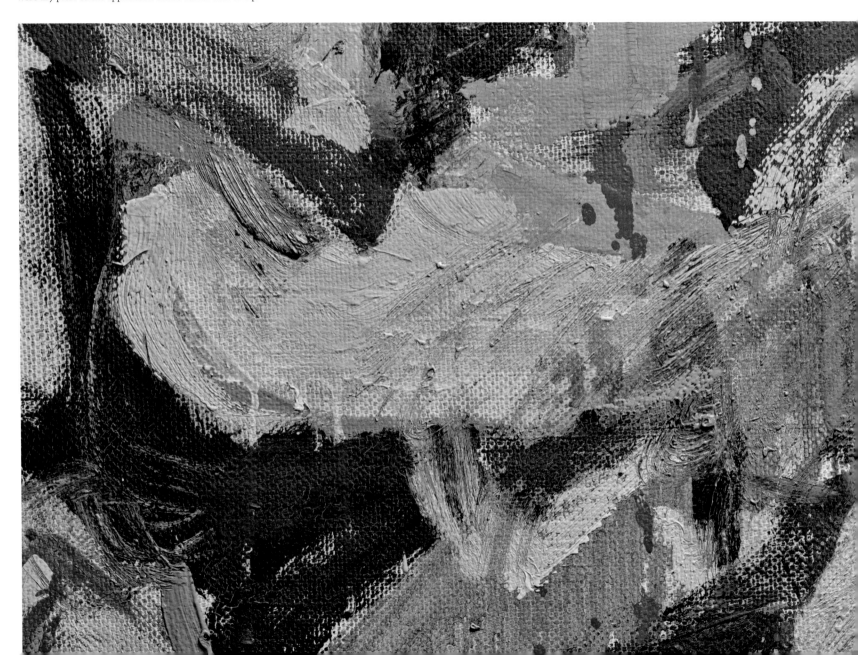

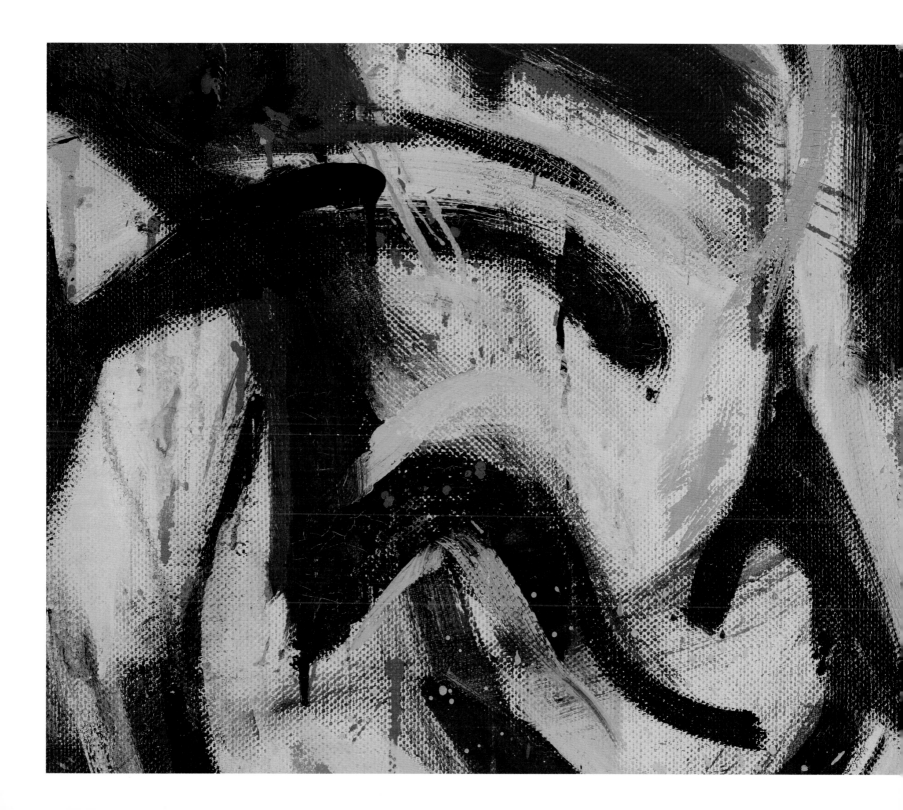

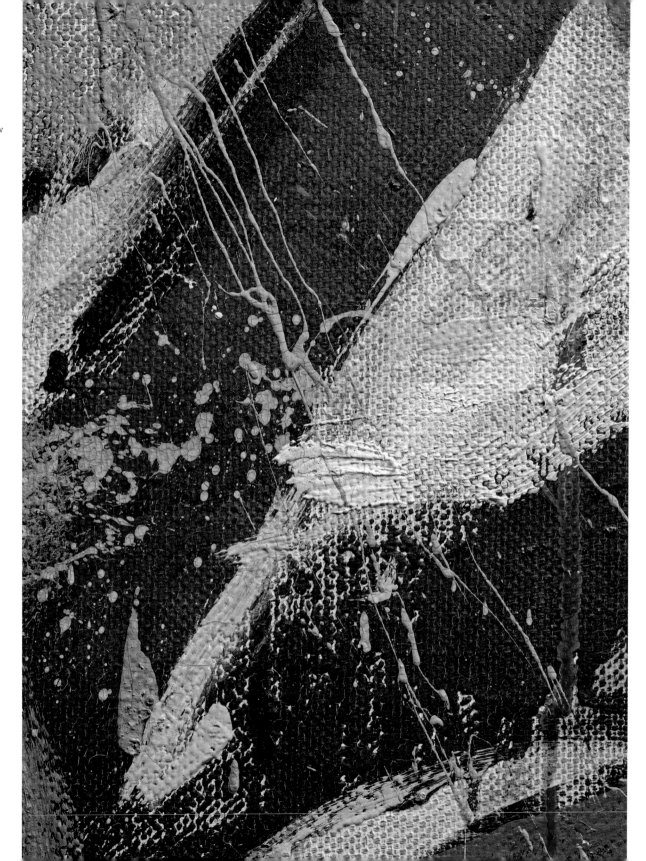

FIGURE 34
Detail of *Mural* (lower right) showing skeins of delicate pink that foreshadow Pollock's later drip technique.

THE COMPOSITION

As a young man, Pollock studied with the Regionalist painter Thomas Hart Benton, absorbing his figurative approach to painting. Pollock moved to New York in fall 1930 to join his brother Charles, who was already studying with Benton at the Art Students League. Pollock arrived just as Benton undertook the painting of the *America Today* mural for the New School for Social Research (see fig. 5). Pollock's two years with Benton would later become, Pollock said, "something against which to react very strongly."[19] By 1943 his work had evolved into a far more innovative and experimental style that incorporated various artistic influences of the period. However, his time with Benton had been formative. It was Benton's approach to laying out the composition of a painting that would have a lasting effect on Pollock, enduring long after he had turned away from his teacher's figurative style. The influence of Benton's approach to composition is evident even in *Mural*, as Ellen Landau notes in her essay (see fig. 18).[20] The dark brown "Bentonian" structure of *Mural*—the tall, thin, stick figures that process across the work from right to left,[21] becoming more calligraphic as they proceed—can be readily sensed in normal viewing of the painting. This compositional device can be isolated by hyperspectral imaging, which exploits specific spectral absorptions associated with the umber pigment that is a principal constituent of these passages of paint (fig. 35b).

Although the dark brown Bentonian forms clearly play a crucial role in the composition of *Mural* and comprise some of the earliest passages of painting in the piece, technical examination of the work has revealed that they are not the first of Pollock's painterly gestures on the canvas; the first paint applications, it seems, are in quite a different color. Close visual observation of the painting's surface, in combination with stratigraphic evidence from paint cross sections and analytical imaging, suggests that the dark, umber-based paints used at the very early stage in the development of the composition almost always lie over, and have some wet-in-wet interaction with, three other paints in different colors, seemingly in descending order: a (cadmium) red, a dark teal that is rich in cerulean blue, and a (cadmium) lemon yellow. If, as the evidence seems to suggest, the cadmium lemon yellow paint is the first in this early sequence, then this represents a bold and surprising approach by Pollock to breaking the ice represented by the blank, white-primed canvas; the broad, fluid, yellow strokes prefigure the dark, umber Bentonian architecture. It seems that the essential skeleton of the composition was first laid down using a sequence of four paints—cadmium lemon yellow, cerulean-rich dark teal, cadmium red, and umber—all very diluted with solvent and applied vigorously in broad, sweeping, dynamic gestures. The wet-in-wet interactions of these four paints, which can be seen both on the painting's surface and in cross sections, suggest they were applied close together in time, possibly in a short, vigorous burst of creative activity. It is tempting to speculate that the dramatic genesis embodied in these four paints has some connection to the myths about the rapid execution of the work.

HYPERSPECTRAL IMAGES

FIGURES 35A–F

Comparison of *Mural* (a) with hyperspectral images corresponding to particular paint types: (b) umber, (c) phthalocyanine green, (d) cerulean blue, (e) cobalt blue, and (f) silicate-rich retail trade paint. The raw hyperspectral images have been subjected to inversion and filtering to render the occurrences of each paint type as dark fields against a light background. Analysis and images: John Delaney, Senior Imaging Scientist, National Gallery of Art, Washington, DC

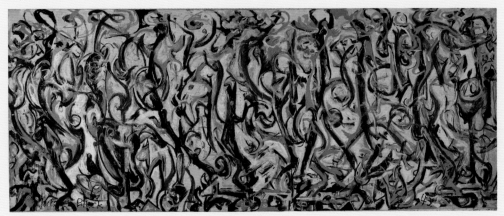

FIGURE 35A

FIGURE 35B **UMBER**

FIGURE 35C **PHTHALOCYANINE GREEN**

FIGURE 35D **CERULEAN BLUE**

FIGURE 35E **COBALT BLUE**

FIGURE 35F **RETAIL TRADE PAINT**

THE PAINTS

Scientific analysis of samples from *Mural* has confirmed that Pollock's stated intention "to paint it in oil" did, for the most part, come to pass; that is, the painting is executed almost entirely in oil paints. This fact is confirmed by the various binding medium analyses that have been carried out, which show that virtually all the paints are bound with drying oil.[22]

The principal pigments and pigment combinations identified in the oil paints of *Mural* include the following:

- titanium white (titanium dioxide),[23] which always occurs together with zinc white (zinc oxide)
- vermilion (mercuric sulfide)
- cadmium red (cadmium sulfoselenide)
- alizarin crimson lake[24]
- cadmium yellow medium (cadmium sulfide)
- cadmium lemon or cadmium yellow pale (cadmium sulfide/barium sulfate)
- burnt umber (umber-type iron oxide earth)
- bone black (carbonaceous calcium phosphate)
- phthalo blue (copper phthalocyanine blue)
- phthalo green (copper phthalocyanine green)
- cerulean blue (cobalt stannate)
- cobalt blue (cobalt aluminate)
- viridian (hydrated chromium oxide)

Taken as a whole, the range of pigments and fillers (known to paint technologists as extenders) that occurs in the various oil paints found on *Mural* more strongly reflects an artist's palette than the kinds of commercial oil paints that might be used for industrial or architectural applications. The oil paints used by Pollock on *Mural* generally include few colorless extenders, such as chalk, silica, or clay-type silicates,[25] and for the most part comprise single pigments at relatively high purity, though there are some notable instances of additions of cheaper colorants, as will be described shortly. The impression received from the occurrences and combinations of these pigments is that the stock supplies from which they came were containers (probably tubes) of ready-made artists' quality oil paints perhaps sold under specific shade names commonly associated with each primary colorant. The oil paints used by Pollock in the creation of *Mural* have distinctive patterns of use and special characteristics.

THE WHITE PIGMENTS: TITANIUM DIOXIDE AND ZINC WHITE

Passages of opaque white paint, often with a thick, pasty consistency, occur throughout the painting. Across these various occurrences, this white paint has a consistent composition in which titanium and zinc are the dominant elements, with trace amounts of aluminum and sulfur; the consistency of composition points to a ready-made commercial combination of titanium white and zinc white.[26] This same stock of opaque white paint appears to have been used extensively throughout *Mural* both to reinforce the light reserves between colored linear shapes and to create tints by admixture with other paints, such as the short strokes of bright phthalocyanine blue, the brushed and flicked-on alizarin crimson pink, and the ubiquitous dull gray-green.

THE RED PIGMENTS: VERMILION, CADMIUM RED, AND ALIZARIN CRIMSON LAKE

The red paints on *Mural* are of three distinct types: a scarlet vermilion, a slightly darker and cooler cadmium red, and a transparent crimson, which appears in a few places at full strength (mass tone) but more widely in tint with the titanium/zinc white to make the distinctive strong pink color.

The vermilion occurs most obviously in the red paint splatters that were evidently applied in very liquid form, presumably thinned with a volatile solvent such as turpentine or mineral spirits. In these paints the principal colorant is true vermilion (mercuric sulfide, HgS), but red lead (lead tetroxide, Pb_3O_4) and an organic pigment, toluidine red (Pigment Red 3), were also indicated by FTIR and Raman spectroscopy as being present alongside the vermilion.

Cadmium red (cadmium sulfoselenide) occurs most distinctively as the principal colorant of a washy red paint that is clearly connected to an early stage in the evolution of the composition. In a fashion similar to the vermilion paint, FTIR microspectroscopy of the cadmium red paint showed that an organic pigment was present together with the cadmium sulfoselenide; in this case the organic red was indicated as Pigment Red 51, a β-naphthol lake, barium salt.

The inclusions of red lead and toluidine red in the vermilion paint and of Pigment Red 51 in the cadmium red seem far more likely to be a consequence of commercial paint formulation—perhaps for economic reasons, along the lines of a pigment manufacturer or colorman "topping off" a more expensive pigment with one or more colorants that are cheaper—rather than something done by the artist himself.[27]

The transparent crimson paint, which appears at a few locations at full strength but usually in tint with white to give the broadly applied strokes of bright pink and the stringy pink skeins, contains as colorant an alizarin crimson lake pigment on an alumina-based substrate. The alizarin lake always occurs together with abundant colorless extender particles of calcium carbonate and sulfate.

Cross-section samples shown on the following pages come from the locations on the painting below.

THE YELLOW PIGMENTS: CADMIUM YELLOW AND LEMON

Two different cadmium-based yellow pigments occur across the painting in different paints. One is a warm cadmium yellow that consists essentially of cadmium sulfide. The other cadmium yellow pigment/paint is a cool lemon yellow layer that occurred in samples often as the first paint layer above the lead white ground. However, it occurs occasionally also as a thin, diluted paint applied by splattering from the brush. The lemon yellow paint contains a distinctive combination of cadmium sulfide and barium sulfate. As noted above, broad brushstrokes in cadmium lemon yellow were among Pollock's very earliest gestures in paint, if not the first, as the composition started to define itself in the beginning stage of painting; but, as is the case with many of the dominant colors, it also gets deployed later in the more substantive, central phase of the development of the work.

DARK BROWN AND NEAR-BLACK PAINTS

There are many passages of painting across *Mural* that are dark brown to near black, including the anthropomorphic calligraphic gestures of the Bentonian architecture. A natural, umber-type (i.e., manganese-rich) iron oxide earth pigment (possibly burnt umber, based on its hue) is a consistent feature of the dark brown paints.[28] These are the only instances of Pollock using a natural earth pigment in the creation of *Mural*; all the other pigments are man-made. However, quite distinctively in this piece, for the dark paints that tend more toward black, the umber-type earth pigment is mixed with bone black to give additional depth to the paint.

FIGURE 36A

Cross section from a dark, phthalocyanine green brushstroke that lies over pink and lemon yellow illustrated in figure 36b. The lemon yellow paint contains some particles of cerulean blue at its surface. The phthalocyanine green paint seems to be rich in medium; as a thin skin of medium has formed at its surface.

6 Varnish (not original)

5 Dark blue-green paint: chlorinated phthalocyanine green, with skin of medium (5b) at surface

4 Pink paint: alizarin crimson, titanium white, and zinc white

3 Thin, pale cadmium lemon yellow paint: cadmium sulfide and barium sulfate; isolated particles of cerulean blue

2 Upper lead white priming

1 Lower zinc white priming

FIGURE 36B

Site of the dark green curved brushstroke, lower center, from which the sample illustrated in figure 36a was obtained.

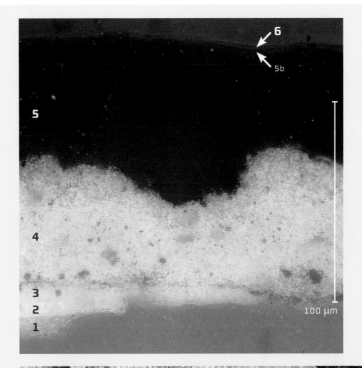

FIGURE 37A

Cross section from the passage of dark blue-black paint illustrated in figure 37b. The sample has a complex layer structure; the first three layers (after the sizing and priming)—pale cadmium lemon, followed by teal rich in cerulean blue, then dark brown composed of umber with some bone black—represent a sequence that occurs at many locations across the painting. Together with the cadmium red that follows the cerulean-rich teal, these paints correspond to Pollock's first broad applications that start to define the overall composition. Here the cerulean-rich teal paint can be seen to have some wet-in-wet interaction with the cadmium lemon yellow below, suggesting that the lemon yellow was still wet or soft when the teal paint was applied.

9 Varnish (not original)
8 Brown-black paint
7 Green-blue paint in which some substructure is evident: zone 7a is phthalocyanine green; zone 7b is rich in medium and contains cerulean blue
6 Dark brown paint: umber and bone black
5 Discontinuous teal-colored paint: cerulean blue, with small amounts of umber and viridian, and isolated particles of organic red
4 Thin cadmium lemon yellow paint (cadmium sulfide/barium sulfate)
3 Upper lead white priming
2 Lower zinc white priming
1 Canvas sizing and entrained wax lining adhesive

FIGURE 37B

Location from which the sample shown in figure 37a was obtained. The strokes of lemon yellow and teal visible on the right, beneath the very dark paints, correspond to the paint layers of those colors visible in the cross-section sample.

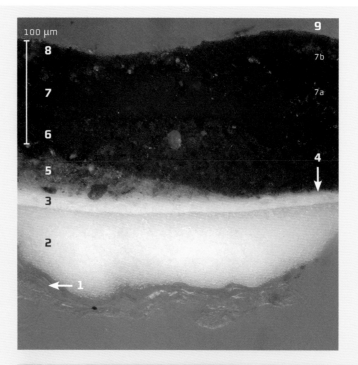

THE BLUES AND GREENS

Colors in the hue range blue through green are important compositional features in *Mural*; there are a wide range of paints of varying tonality and chroma that are blue, green-blue, teal, or gray-green. The complexity of colors in the blue-to-green range is well reflected in the pigments identified in this set of paints: copper phthalocyanine blue (PG15),[29] copper phthalo-cyanine green (PG7), cerulean blue (cobalt stannate), cobalt blue (cobalt aluminate), and viridian (hydrated chromium oxide) are the core colorants, occurring in some cases alone and in others in quite complex mixtures.

Copper phthalocyanine blue occurs mixed with the titanium/zinc white in pure blue paints of medium tonality, most of which are linear and curvilinear strokes applied with about a ½-in.-wide brush. A similar mode of application occurs also for paints of phthalocyanine green, which comprise both light, bright turquoise tints (with titanium/zinc white) and very dark, sat-urated greens of the pigment at full strength.[30] The distribution and application of the green phthalocyanine paints (figs. 36a–b), which add lively detail and strength to the contours of the larger shapes of the composition, can be seen in hyperspectral images acquired using absorption bands specific to this colorant (figs. 35c).

Besides these instances of the phthalocyanine blue and green pigments used relatively pure, one of the most distinctive features of Pollock's practice in the painting of *Mural* was his inclination to create various shades of blue and green-blue using mixtures that feature various combinations of cobalt blue, cerulean blue, and viridian, occasionally also with the phthalos and sometimes with additions of other colorants/paints such as umber-type earth. These complex mixed blues and green-blues occur widely across the painting and are important elements in the composition, contrasting with the yellows, reds, and pink.

Cerulean blue seems to be a signature colorant in *Mural*, and it appears in quite a variety of paints, both very early in the evolution of the composition—as in the broad, washy strokes of dark teal that are part of the first series of paint applications on which the composition is built (fig. 37a)—and later in the main phase of compositional development, as in the ascending strong blue shape in the very center of the painting (fig. 38). This shape is quite heavily worked by Pol-lock—perhaps reflecting its importance for anchoring the composition—and consists of several different applications of blue paint, based on both cerulean blue and cobalt blue.

While cobalt blue occurs in various paints broadly across *Mural*, often mixed with other colorants, the distribution of paints rich in this pigment has a rather surprising pattern, as revealed by the hyperspectral image acquired using its specific absorption bands (see fig. 35e). Cobalt blue–rich paints occur predominantly in the left two-thirds of the painting and are associ-ated with Pollock's campaign of late edits/retouching that postdate the three photographs of the piece taken in his studio as it approached completion (see fig. 27).

It is appropriate to give special mention here to the gray-green that occurs through-out the painting and that has a distinctive role in the composition.[31] This paint is composed of

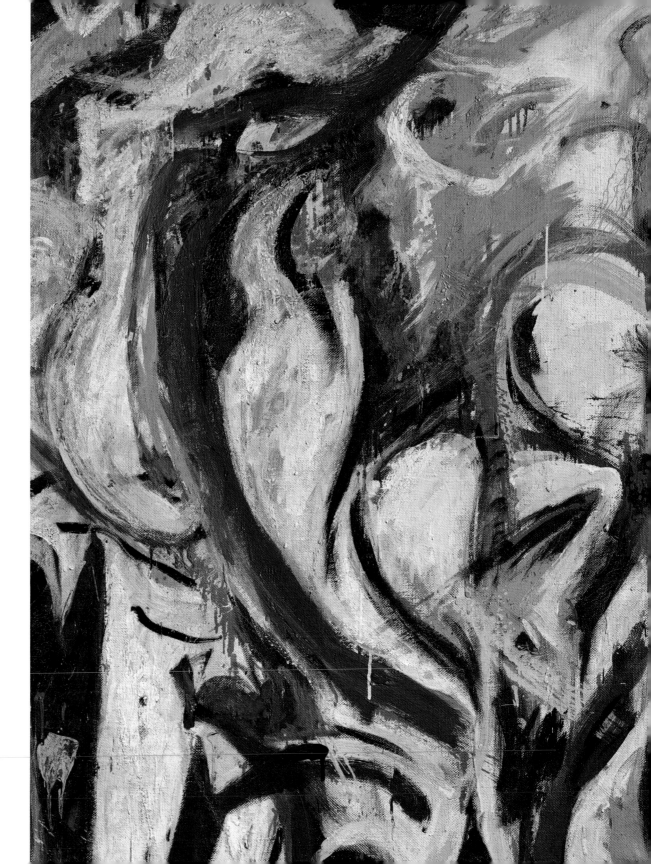

FIGURE 38

Detail of *Mural* (top center) featuring an ascending strong blue shape made with repeated applications of blue paint. The heavy working of this passage reflects its importance as an anchoring compositional element.

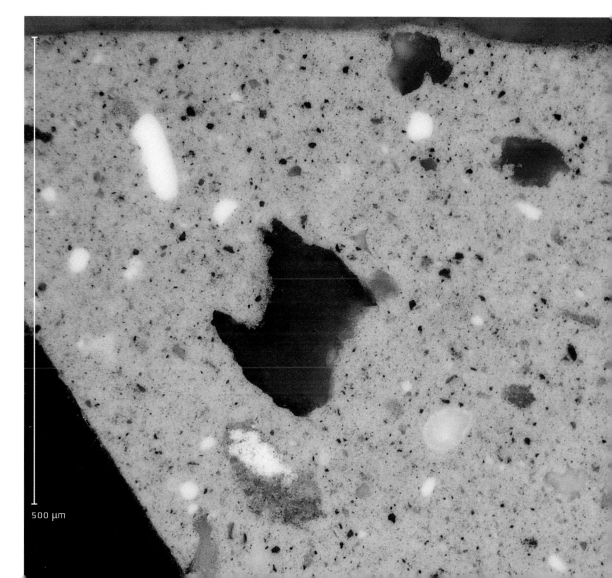

FIGURE 39

Cross section of the dull, gray-green paint that occurs throughout the painting, composed of a complex mixture of pigments, including titanium dioxide, zinc oxide, viridian, phthalocyanine green, cadmium yellow, cadmium red, vermilion, bone black, umber, and red lead, together with barium sulfate, aluminosilicates, and calcium carbonate.

a complex mixture of pigments in which the following have been identified in greater or lesser abundance: titanium dioxide, zinc oxide, viridian, phthalocyanine green (PG7), cadmium yellow, cadmium red, vermilion, bone black, iron oxide, and red lead, together with barium sulfate, aluminosilicates, and calcium carbonate (fig. 39). All these components occur in particular paints found elsewhere on the painting, and it might be surmised that the gray-green paint is actually a mix made by Pollock using stocks of specific colors that he had been using elsewhere in pure(r) form. Given the limitations on "representativeness" inherent in the analysis of tiny paint samples, there is perhaps sufficient evidence to suggest that all paints of this color, regardless of the stage in the painting process at which they occur, actually come from the same batch, mixed in the studio by Pollock himself from stocks of other paints he had on hand.

500 μm

FIGURE 40A

Sample taken from the location depicted in figure 40b prepared as a cross section. From the bottom moving upward the various applications of ground and paint can be seen. Two separate applications of the same gray-green paint are visible in the sample, as are two separate coats of off-white retail trade paint.

8 Pale flesh-colored paint: zinc oxide, titanium oxide, and trace cadmium pigment(s)

7 Gray-green paint: a complex mixture that includes zinc oxide, titanium oxide, phthalo green, viridian, bone black, vermilion, and cadmium red

6 Off-white paint: lithopone and silicate retail trade paint bound with casein

5 Splattered pink paint: zinc oxide, titanium oxide, and alizarin crimson

4 Off-white paint: lithopone and silicate retail trade paint bound with casein

3 Gray-green paint: similar in composition to layer **7**

2 Upper lead white priming

1 Lower zinc white priming

FIGURE 40B

Detail of *Mural* showing the site of the sample illustrated in figure 40a, adjacent to a small damaged area in a passage of flesh-pink paint, lower right quadrant. The uppermost stroke of flesh-pink paint can be seen to overlie several other paint applications, including gray-green, off-white, and a thin drip of strong pink.

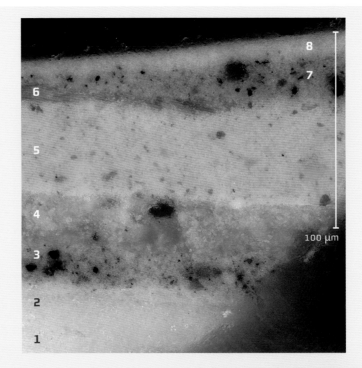

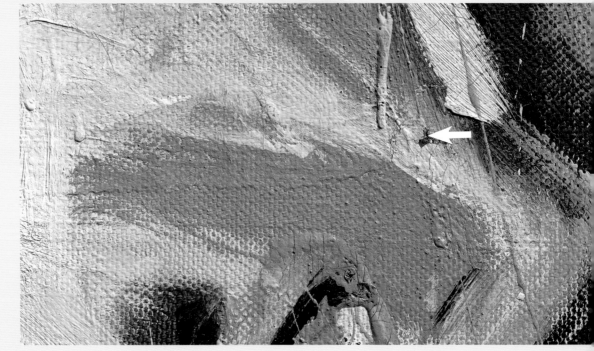

A comparison of the mid-process studio photographs of the painting and the painting as it is now indicates that the addition of passages in the gray-green paint was one of the main operations of Pollock's late editing/retouching phase. Shapes in this color that were added in the late retouching phase occur widely across the painting, especially in the lower left and upper right quadrants; they are somewhat more scarce at the upper left. A sample taken from one of these areas of late retouching (figs. 40a–b) clearly shows two different applications of the same gray-green paint: the first (layer #3), which lies directly on the white ground, comes at a very early stage in the development of the composition; the second (layer #7) is part of the campaign of late retouching by Pollock after the studio photographs had been taken.

A TECHNICAL IDIOSYNCRASY: RETAIL TRADE PAINT

Quite early in the process of analyzing the paint samples from *Mural*, it was noticed that one particular paint, which occurred in a number of the samples, had a distinctive pigment composition and appearance, quite different from all the other paints from which the painting was created. A type of paint other than artists' oils was suspected. The paint is off-white in color, and it appears now as semiopaque; it contains large, transparent, platelike colorless particles embedded in a matrix containing fine, relatively opaque white particles (figs. 41a–b). All paints in this group have been found to be similarly composed of lithopone (barium sulfate coprecipitated with zinc sulfide) with silicate extenders of different types. Regarding the silicate component, kaolinite was indicated both by FTIR spectroscopy and X-ray diffraction (XRD), but other silicates are probably also present (elemental compositions obtained by ESEM-EDS pointed weakly to the presence of talc and mica, which was also weakly indicated by XRD). The adoption of relatively cheap colorless pigments and extenders in this paint over more conventional opaque white pigments such as lead, zinc, or titanium white points to this not being an artists' quality paint but a product more characteristic of retail trade paint.[32]

Once the viewer learns to recognize this paint, it can be spotted widely across the work, mostly in the light reserves between the linear colored forms. In many instances, there is clear evidence that this paint was quite fluid when applied: there are numerous drip lines from areas of this paint, some quite long that run downward, over and across other paints.[33] The off-white paint is stiff and brittle and prone to flaking; typically the delamination is at or near the interface between the off-white paint and a lower paint layer (a thin residue of which remains attached to the underside of the flake of off-white), which might suggest both poor adhesion of the former to the latter and, possibly, some contractive force applied by it to the underlying layers. At other places on the painting where there has been accidental mixing of the off-white paint with still-wet earlier applications (of oil), there are more physical indications of imperfect compatibility of the off-white with the oil paints: reticulation, resisting, and pasty consistency. The probable cause of these incompatibility phenomena was revealed by chemical analysis of the binding medium of the off-white lithopone and silicate paint: the binder was positively identified as casein, a proteinaceous binder

FIGURE 41A

Cross section from the location indicated in figure 41b. The sample comprises mostly a thick layer of the retail trade paint composed of lithopone and silicates bound in a water-based casein medium, which is applied over a layer of dark gray-brown oil paint.

5 Off-white paint: lithopone and silicate retail
 trade paint bound with casein
4 Cool, medium brown paint; oil medium
3 Upper lead white priming
2 Lower zinc white priming
1 Canvas sizing

FIGURE 41B

Detail of *Mural* showing the site from which the sample illustrated in figure 41a was obtained. Here a passage of the off-white retail trade paint mixes with an earlier, still-wet application of oil-based brown paint. This area has been subject to flaking; in some places the off-white paint can be seen to have pulled off the underlying layers down to the bare canvas.

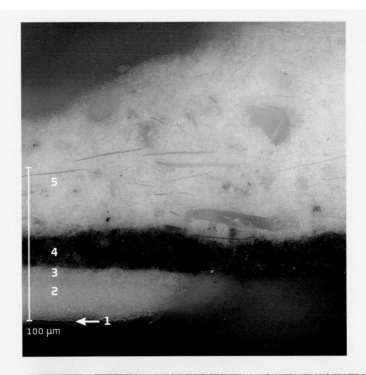

derived from milk. No oil is present; this is not a casein-oil, or oleocasein, paint but one that was originally water based.[34] The various incompatibility phenomena of resisting, reticulation, and so on almost certainly derive from Pollock's choice, for whatever reason, of a water-based paint in the middle of his process of creating his great *Mural* in oil paint; water and oil, after all, don't mix. The (lithopone and silicate) casein paint is interpreted as a retail trade paint, perhaps an economy house paint intended for use on interior walls.[35]

The reason for Pollock's choice of this casein paint is one of the most intriguing questions emerging from the technical study of the painting. As we have seen, the early mid-process photographs of *Mural* in Pollock's studio (see fig. 27) show that the passages in which this paint was used were all present before the campaign of late edits/retouching—the long drips of this obviously very fluid paint are clearly evident—and the paint seems originally to have been considerably more opaque than it now appears: where it lies over darker paint, it is now quite transparent, ghostly, and poorly covering (see fig. 30). Clues as to why Pollock might have resorted to this paint can be found in its distribution across the painting: it is mostly in the light reserves between the linear colored forms. It seems that Pollock used this paint, mid-process and more than once, for the specific purpose of redefining the light reserves between these forms;[36] we might imagine that the properties of opacity/good covering power (at least originally) and quick drying were foremost in his mind when he reached for the pot of water-based retail trade paint rather than an opaque white oil paint.[37,38] The painterly purpose of the off-white retail trade paint—to fill in the light background spaces—can be sensed from a hyperspectral image (see fig. 35f) acquired using a near-infrared absorption band associated with the silicate (clay-type) extenders that represent a substantial portion of the pigment constituents. The off-white retail trade paint was not applied near the upper edge of the painting: there the white ground mostly remains exposed to render the light background reserves.

POLLOCK'S FINISHING TOUCHES TO *MURAL*

Several Pollock scholars have in the past presented three "snapshots" of the left, middle, and right sections of *Mural* that were taken in his studio at some moment as the painting approached completion (see fig. 27). These are useful pieces of evidence concerning the artist's final edits and retouchings to bring the work to its finished state. The painting is clearly quite close to completion; all the essential compositional features have been laid in, and what remains to be done is defining, clarifying, and finessing, strengthening the linear forms and solidifying the light background reserves.[39]

What the later retouching by Pollock actually involved was neatly summarized by O'Connor:

> The entire surface of the work, which was painted leaning against the wall[,] . . . was covered with splatters and paint trailings only some of which appear in the finished work. Not only did Pollock remove the more unsightly of these, he carefully integrated others into his design, and in some places filled in new elements or masked others. This is especially noticeable in the lower left corner. . . . Pollock carefully went over his exuberantly created "first draft" of the painting, editing out a lot of slapdash elements and adjusting others to create a design that worked visually overall.[40]

Nothing in our recent in-depth technical study of *Mural* tends to counter these general observations. The lower left quadrant does seem to have received considerably more attention than other parts of the painting during the retouching stage,[41] and clearly much of the retouching serves to deal with the paint drips, especially those from the very fluid retail trade paint, which, being vertical, disrupt the continuity of many of the slanted curvilinear forms.[42] O'Connor believed, however, that there was "clear evidence of at least two campaigns of retouching, most probably done before the painting was moved from the studio, and that the underlying paint had more or less dried before both."[43]

These conclusions were informed by the observations on *Mural* by Carol Mancusi-Ungaro, which invoked also two later photographs of Pollock standing in front of the painting:

> Justifiably proud of his accomplishment, Pollock allowed *Mural* to be photographed in his studio. . . . The painting also appears in a photograph taken three years later, this time with him standing in front of it, in the lobby of Guggenheim's Art of This Century gallery.[44] . . . In the interim Pollock had reinforced some forms with a dark blue paint, while constructing other shapes and filling in blank spaces with a lighter blue tone.[45] Already visible in a photograph of Pollock and Guggenheim with the painting in her townhouse[,] . . . this final reworking, which may represent yet another campaign, surely must have occurred before the painting left his studio.[46]

On the whole, our technical study leads to conclusions about Pollock's technique on *Mural* that are generally consistent with those of O'Connor and Mancusi-Ungaro: despite the apparent chaos of the vigorously brushed and splattered paint and the rampant intertwined curvilinear shapes, there is an underlying deliberateness in the execution, and at the "retouching" stage, this deliberateness does indeed lean toward carefulness. However, with the additional technical evidence from analytical imaging and paint analysis that has been generated in our study, we can add some refinements to those earlier interpretations. First, we have found no evidence to suggest that the retouching Pollock did to bring the work to completion, after the moment it was photographed in the studio, was done in more than one campaign: the physical evidence of the painting itself suggests all the final edits were done essentially in a single campaign. The range of paints used in this campaign is, from our examination, somewhat broader than Mancusi-Ungaro's pairing of dark blue paint (our dark green-blue) and lighter blue tone (our gray-green), though these are clearly the most abundant and widespread of the passages of retouching. The late retouching campaign includes several other paints: an opaque (titanium/zinc) white, a pinkish flesh color, a dark brown-black, and a pale warm yellow paint. Many of the light background reserves received deliberate attention at this late stage with the titanium/zinc white and the pinkish flesh color. However, the fluid white retail trade paint that had been used earlier for the light background reserves does not seem to have been used in the campaign of late edits/retouching; the retail trade paint is confined only to the "first draft" phase. The narrow strokes of phthalocyanine blue that occur widely across the painting are visible in the mid-process photographs and therefore prefigure the late-stage edits, as do all the fluid splatters in vermilion and the two different cadmium yellow paints.

A careful comparison of a map of the late edits/retouching and the hyperspectral image obtained for cobalt blue shows a striking correspondence between the two (see fig. 35e). While cobalt blue does seem to occur in some paints from the main, first-draft campaign of painting, distributed across the whole area of the work, the majority of cobalt blue–rich passages of paint lie mostly on the left two-thirds of the picture and are concentrated in the center and lower left quadrant; the majority of these passages correspond to the late edits/retouching in dark green-blue paint. This paint is typified, for example, by layer #5 of a sample from near the left edge (figs. 42a–b): cobalt blue is the main constituent of that paint, which is a complex mix with umber, bone black, viridian, and a small amount of titanium/zinc white and cerulean blue. Curiously, the late set of retouchings in this dark green-blue, cobalt blue–rich paint stops rather abruptly about two-thirds of the way across the painting from the left side, for reasons that can only be speculated. The distinctive ascending "hook" shape at the center right (fig. 43) is the farthest to the right of that series of artist retouchings. Perhaps Pollock felt that the right third of the painting, where the dark Bentonian architecture remains quite prominent, needed less strengthening of the dark forms, or perhaps—more prosaically—he simply ran out of that particular mix of paint.

FIGURE 42A

Cross section from the location indicated in figure 42b. A dark green-blue paint that is connected with Pollock's campaign of late retouching lies over a drip of cadmium yellow paint, which lies over an initial paint stroke of dark brown.

6 Varnish (not original)

5 Dark green-blue paint: mostly cobalt blue and umber-type earth with a small amount of bone black, titanium zinc white, and viridian and a trace of cerulean blue

4 Drip of warm yellow paint: cadmium yellow

3 Dark brown paint: umber-type natural iron oxide earth and bone black

2 Opaque white ground

1 Semiopaque white ground

FIGURE 42B

Detail of *Mural* showing the site from which the sample illustrated in figure 42a was obtained. The dark diagonal stroke that covers drips of warm yellow is part of Pollock's campaign of late retouching.

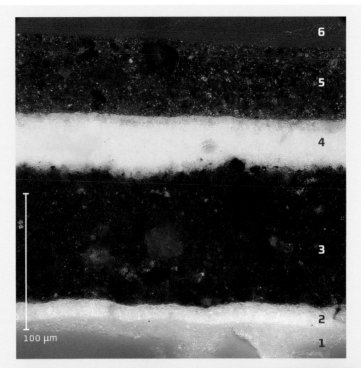

FIGURE 43

Detail of *Mural* (center right) with a dark
hook shape that is the farthest-right use
of cobalt blue–rich paint.

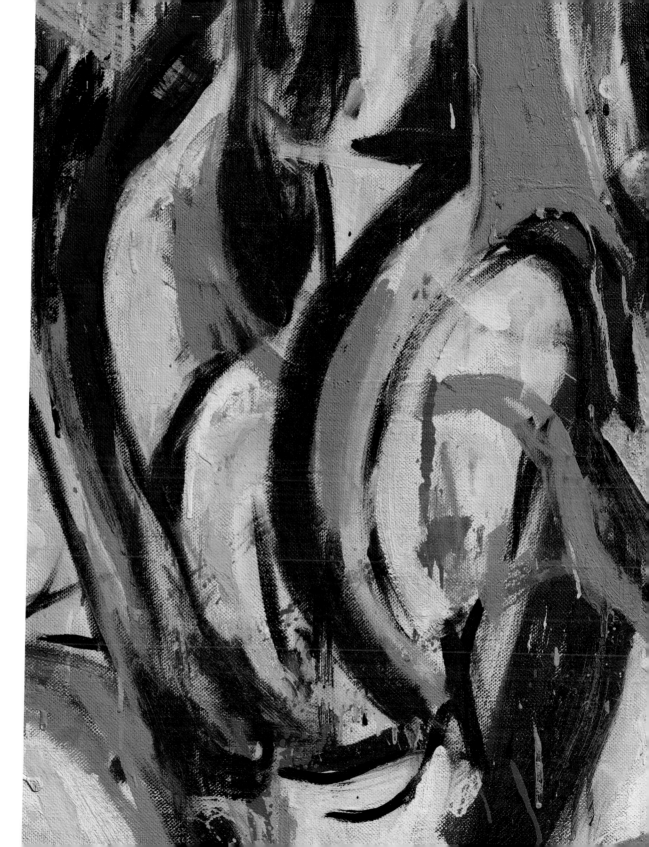

THE INSTALLATION

Traditionally a mural is painted directly on a wall. However, in anticipation of Guggenheim leaving New York at some point (she had always planned to return to Europe once the war was over), Marcel Duchamp suggested that Pollock paint the work on canvas,[47] in case this came to pass and *Mural* had to be moved. Varying accounts of the dimensions of the space have created confusion, both then and now, and it is difficult to ascertain the actual course of events.

Guggenheim's several autobiographies are the source of a number of contradictory accounts about the problems connected with the installation of *Mural*.[48] While these stories are entertaining and dramatic—involving intriguing tales of Pollock's sobriety (or lack thereof) and subsequent notoriously inappropriate behavior (adding to or perhaps starting the evolution of the "bad boy" reputation)—the only pertinent details of these stories for our purposes here are how these events may have had an impact on *Mural*'s physical makeup.

Pollock himself added to this confusion. In his initial letter to Charles in July 1943, he describes the commission as "8' 11½" × 19' 9"" (107½ × 237 in. [273.1 × 602 cm]),while in a letter to his brother Frank in January 1944 he gives the dimensions as "8 feet by 20 feet" (96 × 240 in. [243.8 × 609.6 cm]), closer to the actual dimensions of the painting.[49] It is difficult to ascertain who made the mistake, but somehow there was a discrepancy between the dimensions of the painting Pollock made and the dimensions of the space for which it was designed.

There is a much-repeated tale that installation difficulties resulted in trimming of the canvas;[50] however, after study at MoMA in 1998, this scenario was shown to be impossible,[51] as the painting has four intact, unpainted tacking margins. The original edge where the paint stops is completely preserved on all four sides.

Nevertheless, it is possible that the myth evolved out of some truth and that some adjustment to the stretcher (and thus the painting) occurred in order to make the painting fit the space in Guggenheim's hallway. If the stretcher had been reduced very slightly (perhaps no more than 1 in.) and the painting wrapped around the right side of the stretcher, the dimensions of the painting would have been reduced (without the canvas actually being cut) in order to allow the slightly too large painting to fit into the marginally too small space. Indeed, there is a line of tack holes at the right edge of the painting that are in the painted area, unlike the tack holes on the other three edges (fig. 44);[52] while it is difficult to understand the lack of any distinct corresponding cracking in the paint film where this secondary fold line would have been, it may be explained by the flexibility of the relatively young paint at that time.[53]

By November 1943, any dimensional difficulties having been overcome, *Mural* was installed in the entry hall of Guggenheim's townhouse at 155 East Sixty-First Street in New York (fig. 45). The painting would have been an impressive sight, a colorful riot of barely contained energy, and it would have been difficult to view the entire painting at once. Guggenheim's entry hall was only 13½ ft. wide, usually illuminated only by the light from a single window. (There were

FIGURE 44
Detail of *Mural* (right edge) showing tack holes in the painted area, unlike those on the other three edges.

electric lights, but they were rarely used since turning them on resulted in an electrical overload.) The space was 35 ft. in length, with the painting set into an approximately 20-ft. alcove on the right wall. A visitor would have been almost overwhelmed by the painting's massive scale in this small space, and the figures moving across the canvas would have joined Guggenheim's visitors on their walk toward the small hallway and elevator at the back, leading up to her apartment.

In his insightful essay addressing the myths surrounding *Mural*, O'Connor suggests that framing was added at the top and bottom to resolve the dimensional discrepancies. Indeed, this might have been a plausible explanation, since the image of the painting installed appears to show a double molding at the top of the canvas, as if something had been added in order to make the canvas fit. However, recent evidence makes clear that the "framing"—the double molding at the top and the baseboard below—visible in the image of Pollock and Guggenheim standing before the painting (see fig. 19) is in fact the original molding of the house (fig. 46).[54]

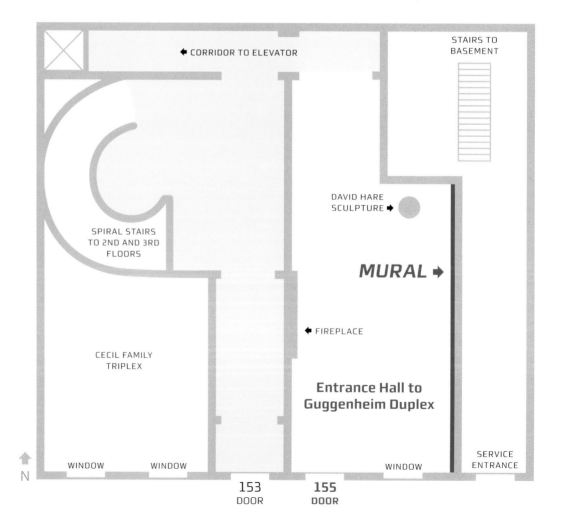

CORRIDOR TO ELEVATOR

STAIRS TO
BASEMENT

DAVID HARE
SCULPTURE �![

SPIRAL STAIRS
TO 2ND AND 3RD
FLOORS

MURAL ➔

◀ FIREPLACE

CECIL FAMILY
TRIPLEX

**Entrance Hall to
Guggenheim Duplex**

N

WINDOW WINDOW

WINDOW

SERVICE
ENTRANCE

153
DOOR

155
DOOR

FIGURE 46

Interior of 155 East Sixty-First Street, New York, 1924. New-York Historical Society, 75881

This photograph, taken in 1924, demonstrates that the double molding was original to the house. (By the time of *Mural*'s installation, the door leading to the staircase had been removed, but the molding was still in place.)

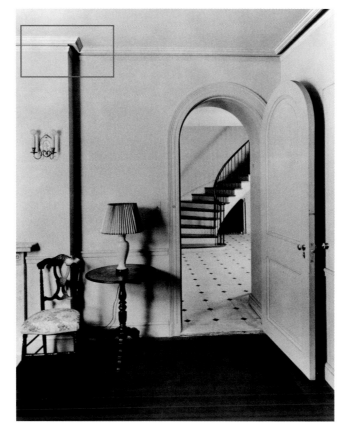

THE TRANSITION FROM
MURAL TO "LARGE MOVABLE PICTURE"

Mural might be considered one of the first of the "large movable pictures" that Pollock referred to in his 1947 Guggenheim Foundation Fellowship application on the changing nature of modern painting:

> I intend to paint large movable pictures which will function between the easel and mural. I have set a precedent in this genre in a large painting for Miss Peggy Guggenheim which was installed in her house and was later shown in the "Large-Scale Paintings" show at the Museum of Modern Art. It is at present on loan at Yale University.
>
> I believe the easel picture to be a dying form, and the tendency of modern feeling is towards the wall picture or mural. I believe the time is not yet ripe for a *full* transition from easel to mural. The pictures I contemplate painting would constitute a halfway state, and an attempt to point out the direction of the future, without arriving there completely.[55]

Mural was not the first mural Pollock painted,[56] but it became a movable painting soon after its original installation, when it was photographed by Herbert Matter for the formal portrait of Pollock with the painting "framed" temporarily using the stretchers bars. It then went on to MoMA for the *Large-Scale Modern Paintings* exhibition, probably prompted in part by the need to give it a more public venue, a reflection of Pollock's growing fame. The installation photographs taken at MoMA show the painting with a signature and a date, which are not evident in earlier photographs (fig. 47). This suggests that the painting was signed and dated in preparation for its entrance into the august company of works by more established artists in the prestigious exhibition.

In his fellowship application Pollock states that the painting went on loan to Yale University.[57] Guggenheim confirms this in her letter to Lester Longman at the University of Iowa in October the following year, when she first offers *Mural* to the university collection.[58] After some negotiation,[59] Iowa accepted the donation, and by the early 1950s the painting was hanging in the studio of the University of Iowa School of Art (fig. 48). The painting would later hang in the main library, before the founding of the University of Iowa Museum of Art in 1959.

FIGURE 47
Mural shown with works by Balthus and
Fernand Léger in the important 1947
exhibition *Large-Scale Modern Paintings* at
the Museum of Modern Art, New York.

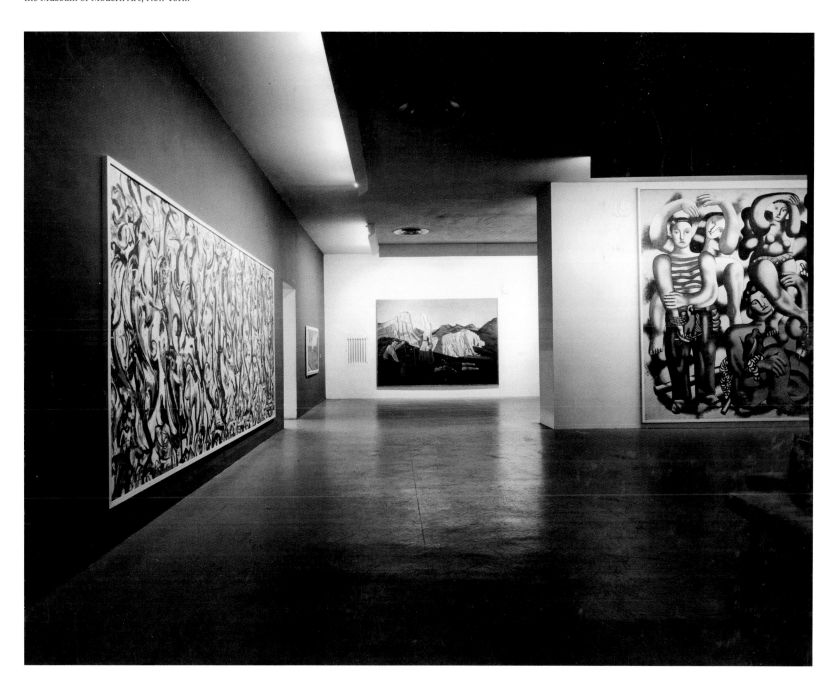

FIGURE 48

Frederick W. Kent (American, 1894–1984),
Mural hanging in an art studio at the University
of Iowa, 1952. Iowa City, University of Iowa
Libraries, Frederick W. Kent Collection of
Photographs

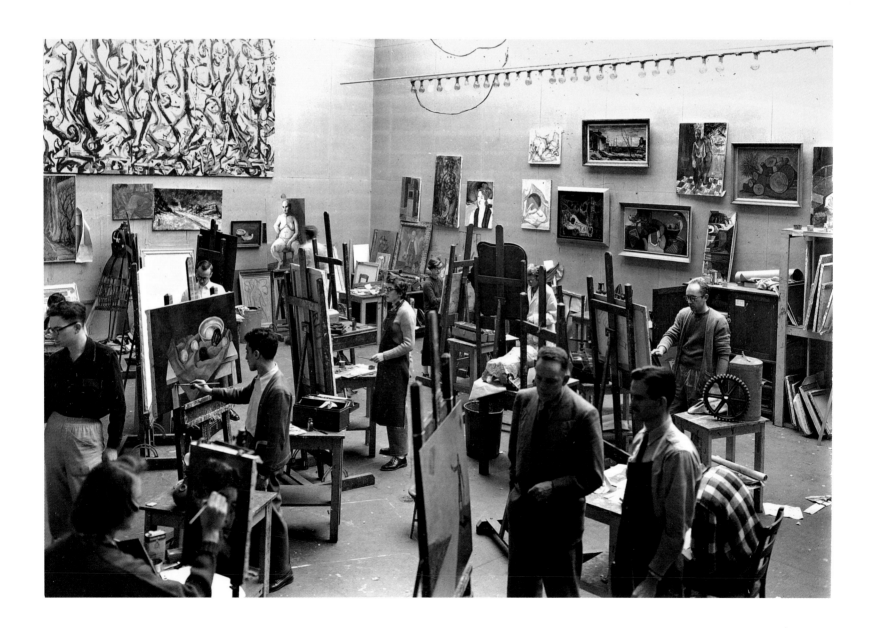

CONSERVATION, 1973

By May 1967 the itinerant life of the painting had taken its toll. While on loan at MoMA, the painting and its condition aroused concern among conservators, prompting a letter to Frank Seiberling, then director of the University of Iowa School of Art. The stretcher was described as "inadequate," not properly supporting the canvas, and "cracked in one place." The result was cracking and lifting paint, to the point that parts were "in danger of dropping off."[60]

Louis Pomerantz, formerly conservator of paintings at the Art Institute of Chicago,[61] treated the painting in Iowa in 1973. A new, stronger stretcher was made, and the painting was lined; that is, another canvas was adhered to the back of the original canvas using a wax and resin mixture that consolidated the fragile paint.[62] The painting was then varnished, and the few small paint losses were retouched.[63] Pomerantz carefully noted the size of the painting after the treatment: 8 ft. ⅜ in. on the left edge, 8 ft. 1¼ in. on the right edge; 19 ft. 10 in. at the top, and 19 ft. 9⅞ in. at the bottom. He then identified the new turnover edges of the painting as forming "equal measurements on all sides without cutting off any of the original painted surface"—effectively squaring off the no-longer square painting.[64] Pomerantz noted, "This meant exposing considerable areas of white primed surfaces which formerly had been turned under on its stretcher frame" (i.e., the former tacking margins).[65] He also stated, "It was decided that the unpainted exposed surfaces could be carefully masked out in the reframing process."[66] However, a frame was never constructed for the painting, and the tacking margins unfortunately remained visible on the painting's face.

CONDITION, 2012

In July 2012 it was evident that further conservation intervention was needed to preserve and present the work in the best possible manner. The painting's early history had created particular problems for both the stability of the complex paint layers and the large canvas support. The conservation intervention of 1973 had successfully stabilized the painting but had inadvertently introduced problematic aspects to the painting's appearance and presentation. The acrylic varnish—intended as a protective coating—had not aged well, and although it was not heavily discolored, over the years it had become cloudy, dulling Pollock's bright colors. Furthermore, Pollock generally preferred an unvarnished surface for his paintings, and he had not applied varnish to *Mural*.[67] In fact, he had used a variety of matte and glossy paints to create the work, features completely disguised by the smoothing and veiling qualities of the uniform varnish.

While the lining had preserved the paint layers, the heat and pressure necessary for this process had slightly flattened those areas of the painting where the paint was thicker. More significantly, the added weight of the wax and resin adhesive and the lining canvas was possibly increasing the noticeable sag in the painting (which, we have noted, seems to have been present since its creation), probably still due to a stretcher (albeit new) of insufficient strength for the

FIGURE 49
Mural before treatment.

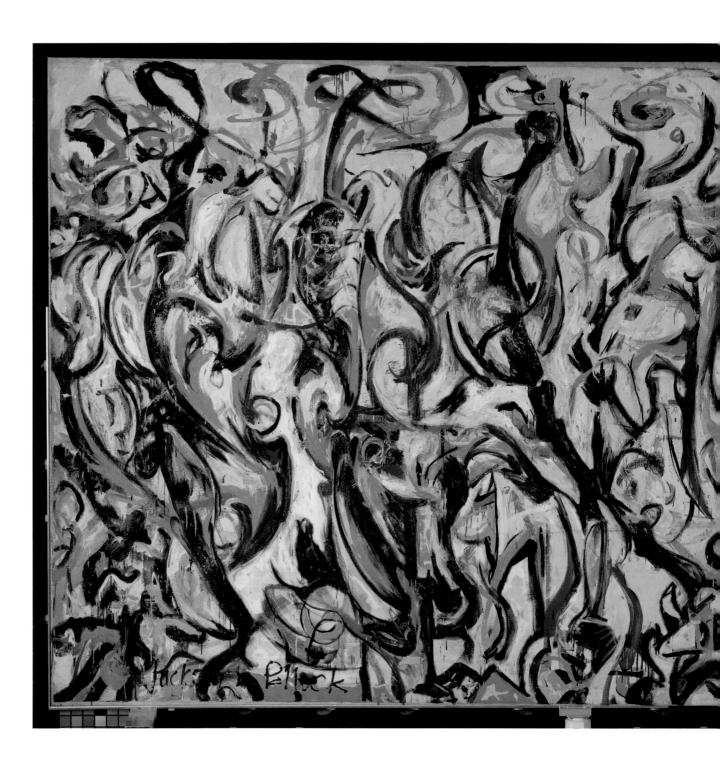

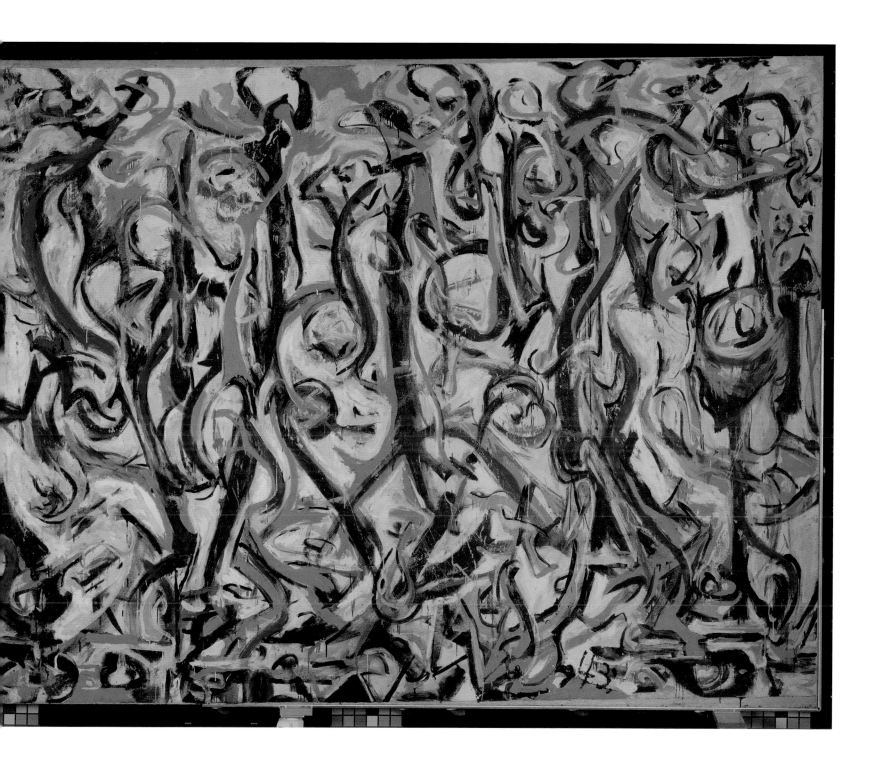

weight of the huge canvas (fig. 49). As discussed above, this lining had also significantly altered the boundaries of the visible painted surface, as the work was now on a stretcher that was slightly larger than the original painting, bringing into view unpainted canvas on the edges that Pollock did not intend to be seen.

CONSERVATION TREATMENT, 2012–2014

The decision to undertake the present treatment was prompted by two main goals:

1. Stabilization and continued conservation of the paint, ground, and support; and
2. Adjustment of the visual presentation of the painting in order to achieve an appearance as close as possible to that which existed when it was first painted.

The removal of the varnish was considered necessary as it related to both goals. Without the varnish the painting returned to a more appropriate appearance, a closer approximation of what Pollock initially intended: a varied and richly painted surface (fig. 50). This step was also essential for the long-term preservation of the painting, as the varnish might become increasingly difficult to remove over time. Safe cleaning of paintings depends on the exploitation of differences in solubility between the original paint and the varnish. If the varnish is not soluble in a solvent that will leave the paint surface unharmed, the painting cannot be cleaned. Acrylic resin varnishes of the type used in the 1973 treatment can be prone to cross-linking over time, becoming increasingly insoluble and requiring increasingly strong solvents for removal. Fortunately, in this case the varnish could still be removed easily, without harming the paint surface.[68]

The structural issues were more complex. The stretcher that had been added during the 1973 treatment needed to be replaced, as over time it had proven insufficiently strong to support the double canvas. In addition, the distortion of the canvas that had started early in the painting's life, reflecting the sagging of the original horizontal stretcher bars, had unfortunately been locked into place by the 1973 lining, and the resulting areas of unpainted canvas tacking edges visible on the face of the painting were visually disturbing.

Three possible approaches to these problems became evident:

1. Replace the existing stretcher with a new, stronger one, retaining essentially the same shape and dimensions that had resulted from the 1973 treatment. While this was the most straightforward approach, it would do nothing to remedy the problem of the unpainted tacking margins on the face of the painting; the problem would be accepted as an unfortunate irreversible change to the painting.
2. Retain the 1973 dimensions but add a frame that could be used to mask the areas of tacking margin now on the face of the painting. *Mural* was not framed in Guggenheim's installation, but it was exhibited with a frame in 1947 at MoMA. Pollock was still alive at this time, and it is

FIGURE 50
Detail of *Mural* (lower right) photographed in
specular light, showing the area before and after
removal of the 1973 varnish.

FIGURE 51
Gathering of specialists in the Paintings Conservation studio at the J. Paul Getty Museum to discuss the study and treatment of *Mural*.

presumed that he approved of the presentation, given that he himself "framed" the painting with the stretcher for his formal portrait with *Mural* that was taken just before it went on view at MoMA.

3. Replace the existing stretcher with a subtly shaped one that followed the now-distorted contours of the painted surface. This would allow the now-visible unpainted areas of canvas to return to their appropriate places on the sides of the painting. However, this approach would create a shape that was no longer completely rectangular, different from the stretcher's original shape as first constructed but repeating its shape as it deformed. While this last approach would present the painting as closely as possible to its original form, we were concerned that it would be visually disturbing to viewers, especially if the painting were to be installed in a way that would echo its original installation in Guggenheim's townhouse. This original installation placed the painting very low on the wall. However, if the painting were hung low, the strong horizontal line created by the junction of the floor and the wall might emphasize the curve of the bottom edge of the painting. Similarly, the strong horizontal line of the upper wall meeting the ceiling might emphasize the distortion at the top.

After consultation with a number of conservation and curatorial specialists, it was decided to proceed with option 3. The old 1973 stretcher was replaced with a new, contoured stretcher, allowing the original tacking edges to return to their appropriate location. The dramatic improvement to the visual appearance of the painting cannot be overestimated. Combined with the subtle and varied surface revealed by the cleaning, the vibrant and dramatic qualities of *Mural* are seen to their full effect once again (figs. 51–53).[69]

FIGURE 52
Conservator removing grime
from the surface of *Mural*.

FIGURE 53

Across top: Members of the Preparations Department place *Mural* face down on a specially designed table.

Bottom from left: Corner showing original canvas adhered to 1973 backing; removal of staples holding the canvas to the stretcher; Getty staff lifting 1973 stretcher from canvas.

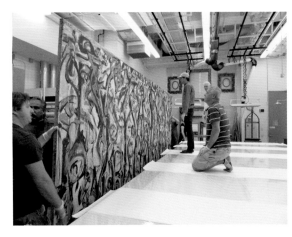

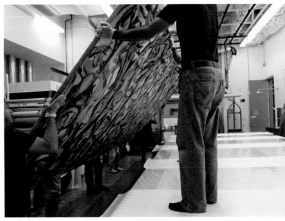

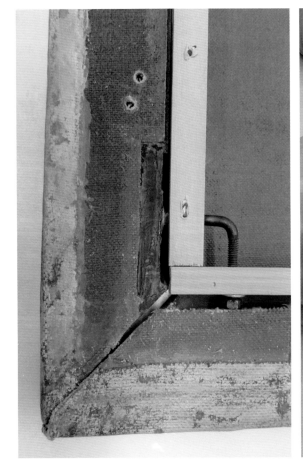

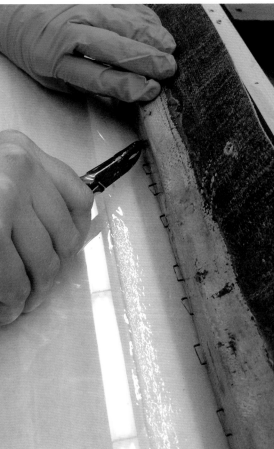

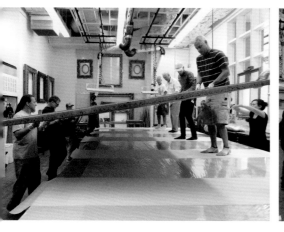
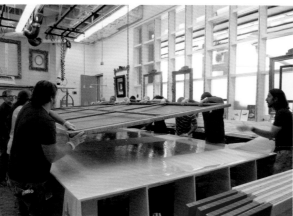
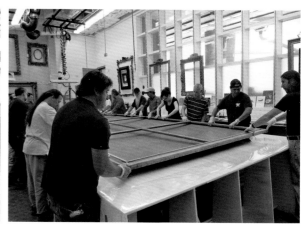

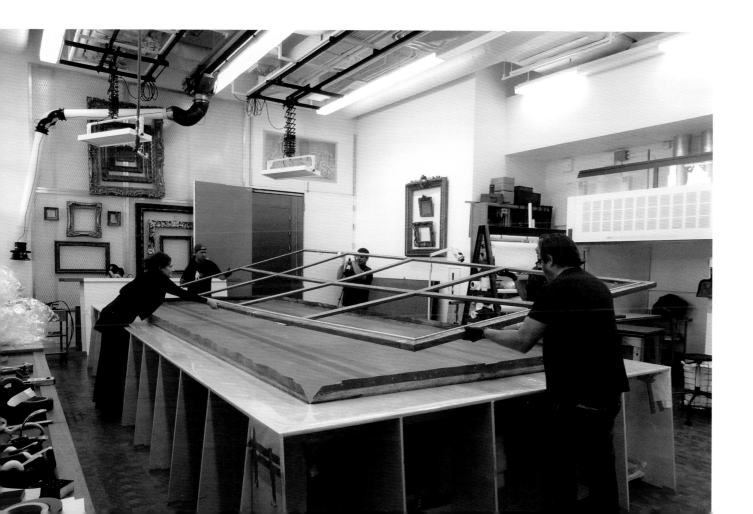

CONCLUSION

The current research into *Mural* has revealed that Pollock combined traditional materials and methods of application with more unconventional ones, achieving great expressive force in his painting technique in parallel with the trajectory of his artistic style at this pivotal moment. While early layers of paint were vigorously and broadly applied, in a free and seemingly spontaneous manner, his careful editing and adjustment of compositional forms with later and successive layers of paint (done in at least two phases) suggests a surprisingly conscious and deliberate working method at the core of his process. Pollock's isolated but significant choice of a less conventional paint anticipates his later well-known experimentation with unconventional paints. Further, his varied paint application—brushing, dabbing, flicking, throwing—could be said to foreshadow the groundbreaking and palpable shift in the painting process that Pollock's later works represent. Guggenheim's adviser Howard Putzel, who was a key figure in the commission of *Mural*, "was curious to see whether a larger scale would release the force contained in Pollock's smaller paintings."[70] Certainly this force is evident in his painting technique on *Mural*.

Investigating one of the more intriguing myths about *Mural*—the legendary stories related by Guggenheim, Krasner, and others describing Pollock creating the painting in a day—has brought forth new information that might help explain this unlikely tale. The sheer amount of paint and complexity of application suggests a longer period of time, and scholars have long pointed out the physical impossibility of completing such a monumental work in slow-drying oil paint in one prolonged creative moment. While the discovery that his initial marks were made in four highly diluted colors—lemon yellow, dark teal, red, and umber—all applied wet-in-wet and visible underneath much of the painting, does present the possibility that he finished some kind of initial composition very rapidly (perhaps even in a single all-night session, providing the basis for the stories), the clear division in paint layers in Pollock's subsequent editing and refining strokes of less dilute, more substantial paint suggests an extended period of application for the majority of the paint that we see now.

While for the most part Pollock adopted regular, traditional artists' materials in *Mural*, his willingness to experiment with both materials and methods of application is clearly already in evidence in 1943. In a radio interview recorded in 1950, Pollock made a statement that seems as relevant to *Mural* as to his later drip paintings:

> WILLIAM WRIGHT. Mr. Pollock, there's been a good deal of controversy and a great many comments have been made regarding your method of painting. Is there something you'd like to tell us about that?
> JACKSON POLLOCK. My opinion is that new needs need new techniques.[71]

NOTES

1. Francis V. O'Connor, "Jackson Pollock's *Mural* for Peggy Guggenheim: Its Legend, Documentation, and Redefinition of Wall Painting," in *Peggy Guggenheim and Frederick Kiesler: The Story of Art of This Century*, ed. Susan Davidson and Philip Rylands (New York: Guggenheim Museum Publications, 2004), 150–69.

2. At 242.9 × 603.9 cm (95⅝ × 237¾ in.), *Mural* is just slightly larger in area than *One: Number 31, 1950* at the Museum of Modern Art (MoMA), New York, which is 269.2 × 518.2 cm (106 × 204 in.). Another very large (266.7 × 513.1 cm [105 × 202 in.]) work from 1950 is *Autumn Rhythm, Number 30*, at the Metropolitan Museum of Art, New York.

3. O'Connor, "Jackson Pollock's *Mural*."

4. Postcard, Jackson Pollock to Lee Krasner, July 15, 1943, Jackson Pollock and Lee Krasner Papers, Archives of American Art, Smithsonian Institution, accessed July 3, 2013, at www.aaa.si.edu/collections/container/viewer/Krasner-Lee-Correspondence-with-Pollock-285932.

5. According to O'Connor, "Jackson Pollock's *Mural*," 153, the contract determined that if more than $2,700 worth of paintings sold, Pollock would receive two-thirds of the proceeds, the gallery one-third. If less than $2,700 worth were sold, Guggenheim would keep the difference in the form of unsold paintings. See Peggy Guggenheim, *Confessions of an Art Addict* (New York: Macmillan, 1960), 105.

6. Letter, Jackson Pollock to Charles Pollock, July 29, 1943. Transcribed as document D44 in Francis V. O'Connor and Eugene Victor Thaw, eds., *Jackson Pollock: A Catalogue Raisonné of Paintings, Drawings, and Other Works*, 4 vols. (New Haven: Yale University Press, 1978), vol. 4, 228.

7. Barbara Rose, "Jackson Pollock at Work: An Interview with Lee Krasner," *Partisan Review* 47, no. 1 (1980): 82–92. Reprinted in Pepe Karmel, ed., *Jackson Pollock: Interviews, Articles, and Reviews* (New York: Museum of Modern Art, 1999), 40. The physical evidence embodied in the painting itself supports Krasner's implication that *Mural* was painted upright, leaning against the studio wall, as in the photograph of Pollock before he started the painting. Where paints show evidence of flow after application (drips and other local collections of material), they are always in the downward direction. There are no indications that any of the paints were applied with the canvas in the horizontal position, a practice used in the later drip/action paintings. The few instances of drips extending across the tacking margin along the bottom edge can be accounted for by the slight downward angle that the edge would have had when the painting was leaning against the wall of Pollock's studio, as pictured before he started the painting. The stringy pink paint applications that must have had a honeylike consistency have been shown by reconstructions to be perfectly reproducible with the canvas vertically oriented and the paint transferred onto the surface from a brush with a vigorous flick of the wrist.

8. For a more complete discussion of the creation legend, see O'Connor, "Jackson Pollock's *Mural*."

9. Letter, Jackson Pollock to Frank Pollock, January 15, 1944. Reproduced as figs. 69a and b in O'Connor, "Jackson Pollock's *Mural*," 155.

10. Letter, Peggy Guggenheim to Emily [Mimi] Coleman Scarborough, postmarked November 12, 1943, Emily Holmes Coleman Papers, Special Collections, University of Delaware Library, Newark. First noted in Mary V. Dearborn, *Mistress of Modernism: The Life of Peggy Guggenheim* (New York: Houghton Mifflin, 2004), 227.

11. For example, O'Connor notes that Krasner told him this directly in the late 1960s. O'Connor, "Jackson Pollock's *Mural*," 166 n. 12.

12. Peggy Guggenheim, *Out of This Century: The Informal Memoirs of Peggy Guggenheim* (New York, Dial Press, 1946), 244–45; and Peggy Guggenheim, *Out of This Century: Confessions of an Art Addict* (New York: Universe Books, 1979), 296, state that Pollock painted it in three hours. Guggenheim, *Confessions of an Art Addict*, 101, says that he painted it in a few hours.

13. This was noted by the conservator Carol Mancusi-Ungaro in her eloquent essay on Pollock's painting technique in connection with the 1998–99 retrospective of his work at MoMA. Carol C. Mancusi-Ungaro, "Jackson Pollock: Response as Dialogue," in *Jackson Pollock: New Approaches*, ed. Kirk Varnedoe and Pepe Karmel (New York: Museum of Modern Art, 1999), 118.

14. The exact circumstances of the purchase of the canvas are not known. O'Connor, "Jackson Pollock's *Mural*," 166 n. 8, cites a 1965 letter to him from Harry Jackson in which Jackson stated that Pollock "told me about a great piece of linen canvas Peggy Guggenheim bought for him to do a mural for her hall on." Whether she provided Pollock with a budget for paints and other materials or whether he had to cover the cost of them himself out of his stipend is not known.

15. The canvas of *Pasiphaë* (Metropolitan Museum of Art, New York), also 1943, has exactly the same weave structure, only oriented differently; that is, it is rotated 90 degrees compared to *Mural*. The tacking margin along the left edge of *Pasiphaë* (viewed from the back) has an unprimed strip of bare canvas toward the edge, which is finished (i.e., it is not a cut edge) and is thus the canvas selvedge; accordingly, the warp threads run vertically. A similar unprimed border occurs along the

top edge, but this leads to a cut edge, which probably means that this is the end of the piece that was cut from a larger piece off the loom before the fabric received its two layers of priming. The similarity of both canvas weave and manner of preparation (double priming of lead white over zinc white) suggests a common origin for the canvases of *Mural* and *Pasiphaë*, the possibility of which will be explored further as this project progresses. The canvas of *Pasiphaë* bears the stamp of the Belgian manufacturer Claessens, which is still in business today; a wonderful short film, probably from the early 1960s, of traditional weaving and preparation of linen canvases for painting can be seen at the manufacturer's website, www.claessenscanvas.com/en. The preparation of a large piece of canvas shown in the film has parallels with what has been found on *Mural*: first a layer of animal glue size (seen in the film applied warm), followed by a first ground/priming (possibly zinc white, as in *Mural*) applied using a large, bladed, spatula-like implement, and a second ground (possibly lead white) applied by brush and then smoothed out by roller. Claessens still makes a heavyweight linen canvas (product type #29) with a basket weave similar to that observed in *Mural* and *Pasiphaë*, which is available primed or unprimed, in widths respectively of 82 in. and 84 in. Interestingly, an advertisement in *Art News* 22, no. 32 (May 17, 1924), for the art supply store Schneider and Co., 2102 Broadway, New York, NY, states that they are the "sole agents" for Victor Claessens Belgian canvas, available in widths of 17 in. to 13 ft. 6 in. and lengths up to 43 yd. in one piece.

16. Macro-X-ray fluorescence (macro-XRF) scanning of a small test area of *Mural*, using the L-series electron energy lines for lead, produced an image that showed widely spaced lateral striations that are probably related to the manner of application of the upper lead ground (see fig. 55).

17. On arrival at the Getty, the painting was on a stretcher dating from the 1973 conservation treatment by Louis Pomerantz. It seems likely that the original Pollock stretcher was being used until the 1973 treatment, but efforts to confirm this have been inconclusive.

18. O'Connor, "Jackson Pollock's *Mural*," 159, 167 n. 36, correctly suggests that the wooden elements in this image may be the stretcher bars serving as the "frame." However, O'Connor expresses doubt because he observes a "lip" that precludes the wooden elements from being a stretcher bar. In fact, this "lip" is merely the expected difference in width between the narrower tenon used to join the stretcher bars at the corners and the full width of the stretcher bar itself. The authors would like to affirm that the wooden elements in the image are indeed stretcher bars, not a frame or molding, as O'Connor hypothesizes. The separated mortise and tenon joints of the stretcher bars are fully visible at the four corners of the painting.

19. "Jackson Pollock: A Questionnaire," *Arts and Architecture* 61, no. 2 (February 1944): 14. See also Karmel, *Interviews*, 15.

20. For Benton's theories of composition, see Thomas Hart Benton, "The Mechanics of Form Organization in Painting," published as a five-part series in *Arts* 10 (November 1926): 285–89; 10 (December 1926): 340–42; 11 (January 1927): 43–44; 11 (February 1927): 95–96; and 11 (March 1927): 145–48.

21. According to O'Connor, "Jackson Pollock's *Mural*," 162, "In *Mural*, as Pollock wrote out its design from left to right you can see this progression develop." Our reading of the painting does not lead to the same conclusion. Rather, we think the inverse is true: the momentum of the composition is directed from right to left, which seems more appropriate to the intended setting of the piece in Guggenheim's entrance hall.

22. On the basis of ratios of (methyl esters of) palmitic and stearic acids, linseed oil is identified as the most common type of oil occurring as paint binder, while walnut oil is indicated for one sample (a vermilion red paint) by virtue of its high palmitate/stearate (P/S) ratio of 3:1. In a small number of samples, binding medium analysis indicated in each the presence of a drying oil but with P/S ratios somewhat lower (<0.9) than would normally be expected for linseed oil. These instances are interpreted as a "modified drying oil," possibly by inclusion of one or more other components in a vehicle that is based on linseed oil; interestingly, these instances of modified drying oil occur for paints that are rich in an umber-type iron oxide earth, which might point to this vehicle being associated with that particular pigment. Analysis of one sample of relatively pure alizarin crimson red (the same red used to make the strong pink paint that occurs widely across the painting) showed the characteristic typical fatty acid ratios of linseed oil but with an additional fatty acid component present, specifically ricinoleic acid (12-hydroxy-9-decenoic acid), which is commonly taken as a marker compound for castor oil. Castor oil is not an uncommon constituent of mid- to late-twentieth-century artists' oil colors; it is a known ingredient, for example, in the Bocour Bellini line of paints. While this finding cannot exclude the possibility of a proportion of a castor oil–derived substance in the paint *binder*, the ricinoleic acid detected could also be associated with the (alizarin crimson) lake pigment. A common ingredient in organic pigment preparation, including anthraquinoid colorants like alizarin crimson, is Turkey Red oil, which is sulfonated castor oil. As Lyde S. Pratt notes, "The preparation of madder [and, by extension, other anthraquinoid] lakes involves, typically, the precipitation of a complex made up of the dyestuff, a metal, usually, calcium, and a fatty acid such as Turkey Red oil on an alumina hydrate base" (Lyde S. Pratt,

The Chemistry and Physics of Organic Pigments [New York: J. Wiley and Sons, 1947], 200). Turkey Red oil is one of a number of surfactant-type substances used as precipitation assistants in the preparation of organic pigments; rosin soaps are another common additive of this type. In our laboratories, markers for ricinoleic acid/castor oil have been detected by gas chromatography/mass spectrometry (GC/MS) in dry powder samples of some organic pigments.

23. In some of the samples comprising the titanium white/zinc white paint, localized domains of stronger fluorescence can be seen under ultraviolet (UV) illumination. The domains of stronger fluorescence correspond with distinct features that occur in environmental scanning electron microscopy (ESEM) backscattered electron (BSE) images in which zinc-rich laminar structures are visible in regions of low relative atomic mass. These features are interpreted as local aggregations of zinc carboxylates (soaps), possibly with some crystalline regions forming at the core of collections of more amorphous material. The presence of metal carboxylates in these paints was indicated by Fourier-transform infrared (FTIR) spectroscopy.

24. The alizarin crimson lake is on an alumina substrate and is extended with calcium carbonate and sulfate.

25. A notable exception to the rule of no extenders in the oil paints is the alizarin crimson lake, all occurrences of which include calcitic extenders (calcium carbonate and sulfate) in moderate proportion; this is a not uncommon situation, even in artists' quality paints, for transparent colors such as the red lakes.

26. Raman spectroscopy confirmed the titanium dioxide as the anatase form.

27. The addition of minor amounts of organic colorants to mineral pigments seems to have been a fairly widespread practice among artists' colormen of the mid- to late twentieth century. For example, quite a number of formulations for Bocour Bellini artists' oil colors, especially red and yellow shades, include combinations of mineral pigments with organic colorants.

28. An unusual phenomenon can be seen in some of the dark brown paint: some layers in cross-section samples show a substratum at the upper surface of the brown paint that is depleted in particles and has stronger fluorescence. This effect is interpreted as a medium-rich surface "skin" connected to both an excess of medium and settling of the pigment, perhaps evidence of Pollock adding extra medium to ready-prepared paints, seen also in certain other paints from *Mural*.

29. The specific subtype of the phthalocyanine blue pigment could not be determined by Raman spectroscopy, but moderate amounts of chlorine were detected by environmental scanning electron microscopy with energy-dispersive X-ray spectroscopy (ESEM-EDS), which tends to suggest the α crystal modification (PB15:1 or 15:2) rather than the β or ε modifications (PB15:3, 15:4; PB15:6), commercial grades of which are not usually chlorinated. See Willy Herbst and Klaus Hunger, *Industrial Organic Pigments: Production, Properties, Applications* (Weinheim: Wiley-VCH, 2004), 441.

30. ESEM-EDS analysis indicated that the phthalocyanine green is a strongly chlorinated type. Commercial grades of PG7 typically contain 14–15 halogen atoms per molecule. PG36 can be excluded, as no bromine was detected. See Herbst and Hunger, *Industrial Organic Pigments*, 441.

31. Our description "gray-green" paint seemingly corresponds to the paint that Mancusi-Ungaro describes as a "lighter blue tone" that Pollock used in a campaign of late edits/retouching for "filling in blank spaces." Mancusi-Ungaro, "Jackson Pollock: Response as Dialogue," 118.

32. Interestingly, in a footnote in their paper on paints used by Pollock in his drip/poured paintings, Lake, Ordonez, and Schilling mention the finding of a beige lithopone and clay paint in the lower layers of Pollock's *There Were Seven in Eight* (ca. 1945; MoMA) that is interpreted as a "commercial paint": "The lithopone and clay composition of the beige paint is not a common pigment mixture in artists' paints, although it has been observed in some early twentieth-century works." The binding medium of the beige lithopone and clay paint in the lower layers of *There Were Seven in Eight* is reported as linseed oil. Susan Lake, Eugena Ordonez, and Michael Schilling, "A Technical Investigation of Paints Used by Jackson Pollock in His Drip or Poured Paintings," in *Modern Art, New Museums: Contributions to the Bilbao Congress, 13–17 September 2004*, ed. Ashok Roy and Perry Smith (London: International Institute for Conservation, 2004), 138 n.3.

33. Covering up the abundant drip lines from the fluid off-white paint, which interrupted the continuity of many of the linear forms of the composition, was one of the main purposes of Pollock's campaign of late edits/retouching.

34. The exact form in which Pollock acquired this paint has not been determined. While this could have been a ready-made liquid paint, it is not impossible that this might alternatively have been a dry powder paint that Pollock made liquid by adding water. Dry powder paints, pigmented with substances such as lithopone, clays, and mica, are reported in the literature of the period: see Robert S. Radcliffe, "Casein Paints," in *Protective and Decorative Coatings*, vol. 3, ed. Joseph J. Mattiello (New York: Wiley, 1943), 468. Mica is mentioned as an additive that improved the brushing of the wet paints and the flexibility of the dried film.

35. For more on casein house paint, see Harriet Standeven, *House Paints, 1900–1960: History and Use* (Los Angeles: Getty Conservation Institute, 2011), 47–52.

36. The off-white (lithopone and silicates) casein paint occurs twice, for example, in the cross-section sample illustrated in figure 40a, above and below a thin line of flicked viscous pink paint.

37. In fact, an opaque white oil paint (comprising a mixture of titanium and zinc white pigment) is similarly used to further define the light background reserves in Pollock's campaign of late edits/retouching.

38. An important original property of the retail trade paint that can be discerned from the mid-process photos of the painting (see fig. 27) is its brightness and opacity (i.e., it had good covering power). Given its transparency now, a loss of opacity over time is strongly suggested.

39. The final retouchings include considerable attention to the definition of the linearity of the edges (which has some bearing on the issues of stretching and framing of the piece). This is most evident along the bottom edge and the top edge, right side. It can be noted in passing that even when he was applying the most vigorously animated paint strokes, Pollock was still quite precise with the edges of the composition, off which his strokes bounce as if by reflection.

40. O'Connor, "Jackson Pollock's *Mural*," 156.

41. The area toward the top left corner is surprisingly free from late-stage edits/retouching.

42. The mid-process photos clearly show the visual impact of the drips of the (obviously very fluid) white retail trade paint; this is especially evident in the photograph of the middle section, where many white vertical drips can be seen cutting across dark lateral and diagonal forms, thus destroying their continuity.

43. In this connection, O'Connor, in "Jackson Pollock's *Mural*," cites Mancusi-Ungaro, "Jackson Pollock: Response as Dialogue," 117–19 and esp. 152 n. 6.

44. This is probably the incorrect location for the photograph of Pollock in front of the completed painting: it is now understood to be Vogue Studio, New York.

45. What for Mancusi-Ungaro is "dark blue" is in our analysis a range of paints in the dark green-blue to near-black range made by mixes of blue paint(s) with umber; and Mancusi-Ungaro's "lighter blue tone" seems to equate to the paint we have called gray-green.

46. Mancusi-Ungaro, "Jackson Pollock: Response as Dialogue,"118.

47. Guggenheim, *Out of This Century: Confessions of an Art Addict*, 295.

48. See Guggenheim, *Out of This Century: Informal Memoirs* and *Out of This Century: Confessions of an Art Addict*.

49. Transcribed as document D44 in O'Connor and Thaw, *Jackson Pollock: A Catalogue Raisonné*, vol. 4, 288.

50. This myth is discussed at length by O'Connor ("Jackson Pollock's *Mural*," 152). He states that the earliest version is found in Guggenheim's autobiography but that it also appears in later scholarly literature, where it is based on a number of unconfirmed sources.

51. Mancusi-Ungaro, "Jackson Pollock: Response as Dialogue," 118.

52. This possibility was first discussed by Carol Mancusi-Ungaro at a meeting at the Getty Museum in January 2013. There are, of course, countless other possible explanations for the odd line of tack holes at the right edge. Whether an early photograph (see fig. 47) of the painting at the MoMA *Large-Scale Modern Paintings* exhibition provides evidence of a difference at the right edge is a question that is still being explored.

53. The authors are indebted to Angelica Zander Rudenstine for her prescient architectural research on the former Guggenheim townhouse (now part of the offices of the Mellon Foundation) during a 2003 renovation of the space. She measured the space in 2003 as approximately 8 ft. 1⅜ in. high by 19 ft. 8 in. wide. Intriguingly, measuring the actual painting to the second set of tack holes yields almost exactly the same width.

54. Again, the authors thank Angelica Zander Rudenstine for sharing her research.

55. Transcribed as document D67 in O'Connor and Thaw, *Jackson Pollock: A Catalogue Raisonné*, vol. 4, 238; also in Karmel, *Interviews*, 17.

56. Pollock proposed one mural and participated in at least two murals before undertaking the Guggenheim commission. Of the two he participated in, one was executed in 1934, in the studio he shared with his brother Sandy, and the other was undertaken in the studio of Harold ("Buz") Faye, sometime in the early 1940s. For details on Pollock's interest in murals, his work as an assistant on murals directed by other artists, the 1950 works as murals, and his later efforts to obtain mural commissions, see Francis V. O'Connor, "A Note about Murals," in *Pollock: A Catalogue Raisonné of Paintings, Drawings, and Other Works, Supplement Number 1* (New York: Pollock-Krasner Foundation, 1995), 52–53.

57. The painting arrived in June 1947 and was sent to Iowa on October 18, 1951. George Heard Hamilton, then associate director of the Yale University Art Gallery, noted that he was sorry "to see it go, but student interest in it … was conspicuous by its absence." Registrar's Office, Yale University Art Gallery, files.

58. Guggenheim writes, "I lent it to New Haven for a year as they had a special place for it but now it is no longer on

exhibition.... It is still in New Haven." Letter, Peggy Guggenheim to Lester Longman, October 3, 1948, University of Iowa records, accessed July 3, 2013, at uima.uiowa.edu/pollock-correspondence.

59. See correspondence between Guggenheim and Longman, University of Iowa records, uima.uiowa.edu/pollock-correspondence.

60. Letter, William S. Lieberman to Dr. Frank A. Seiberling, May 11, 1967, University of Iowa Museum of Art object files.

61. By the early 1970s Pomerantz was in private practice. He was one of the most respected figures in the field.

62. Details of the treatment are on file at the University of Iowa Museum of Art.

63. A brush coating of an acrylic varnish called Soluvar (by Permanent Pigments) was applied to the surface. Small losses to the paint layer were inpainted with Bocour acrylic Magna colors, and the areas of inpainting were then coated with additional Soluvar varnish. For information on Soluvar, see http://cameo.mfa.org/wiki/Soluvar (accessed July 10, 2013). On the possible changes in removability of butyl methacrylate resin varnishes with age, see, for example, Suzanne Quillen Lomax and Sarah L. Fisher, "An Investigation of the Removability of Naturally Aged Synthetic Picture Varnishes," *Journal of the American Institute for Conservation* 29, no. 2 (Autumn 1990): 181–91.

64. Louis Pomerantz, treatment report, 1973, Unversity of Iowa Museum of Art object files, 2.

65. Pomerantz treatment report, 2.

66. Pomerantz treatment report, 2.

67. Letter, Frank Seiberling to Douglas Macagy, January 31, 1962, University of Iowa Museum of Art object files, uima.uiowa.edu/pollock-correspondence.

68. Conservation treatment records on file at the J. Paul Getty Museum.

69. The dimensions of the painting on its new, contoured stretcher are as follows:

Height at left edge: 241.8 cm (95³/₁₆ in.)
Height at center: 242.3 cm (95³/₈ in.)
Height at right edge: 242.9 cm (95⁵/₈ in.)
Width at top edge: 603.1 cm (237⁷/₁₆ in.)
Width at center line: 603.9 cm (237³/₄ in.)
Width at bottom edge: 603.9 cm (237³/₄ in.)

70. Jacqueline Bograd Weld, *Peggy, the Wayward Guggenheim* (New York: E. P. Dutton, 1986), 306.

71. Excerpts from a radio interview with William Wright, recorded in The Springs, Long Island, New York, late 1950, originally broadcast on radio station WERI, Westerly, Rhode Island, 1951. Transcribed in O'Connor and Thaw, *Jackson Pollock: A Catalogue Raisonné*, vol. 4, 248–51; also in Karmel, *Interviews*, 20.

DECONSTRUCTING *MURAL:*
A GUIDE TO READING POLLOCK'S PAINT

ALAN PHENIX

One of the essential, beautiful qualities of great works of art like *Mural* is that they usually defy attempts to gain a perfect understanding of the manner of their creation; they retain a degree of intangible mystery despite all the efforts of modern science and technology to describe the materials and the process by which the artist's vision became concrete. Earlier in this volume, Ellen Landau rightly praised Ed Harris's superb re-creation of the painting of *Mural* in his biopic on Pollock; and while there might be minor points of technical variation in that re-creation from what occurred in reality in late summer and fall 1943, there is little doubt that Harris faithfully captured the manner, the feel, and the spirit of how the artist went about making this remarkable painting.

 Mural is a big painting, and a lot of paint went into its creation. Much of its power comes from the complex intertwined and interconnected linear shapes, all rendered in a riot of color. Clearly intended to make an impact, *Mural* is a difficult painting to comprehend visually, even by specialists. The technical study of the painting that has been undertaken in parallel with the conservation treatment has sought—in addition to simply identifying Pollock's materials—to gain a fuller understanding of his creative process and to peer through the frenzy of different paints to learn more about how the composition evolved from blank canvas to finished work. This endeavor has been achieved through a combination of complementary investigative approaches: close visual examination of the painting's surface; microscopic examination and chemical analysis of paint samples; and new, noninvasive chemical imaging techniques, specifically, hyperspectral imaging (HSI) and macro-X-ray fluorescence (macro-XRF) scanning. The combined body of evidence, which can be extrapolated outward from the microscopic samples across the whole painting, is substantial enough now, we think, to determine with reasonable reliability the composition of any paint application in the work. But understanding paint composition is only part of the story; how the paint was applied and in what sequence are at least as important

FIGURE 54

Detail of *Mural*, (center left). Aided by analytical imaging, twenty-five separate paint applications on the white ground could be identified, as indicated.

questions from the technical standpoint. To a limited extent, insights into the painting process can be gleaned from evidence in tiny cross-section samples; however, exactly what paint layers appear in any given sample will be strongly influenced by the specifics of paint applications at that particular location, which may not be entirely indicative of what is going on more generally across the painting or even a few inches away. The advances in analytical imaging just mentioned have allowed information gathered from tiny samples to be extended to inform a wider understanding of how *Mural* came into being.

At the beginning of the technical study of *Mural*, the area shown on p. 90, just left of the center of the painting, was identified as offering a representative selection of the majority of the different paints and types of application that Pollock employed in the creation of the work. In this area alone, which is approximately 23 × 15½ in. (58.4 × 39.4 cm), well over twenty different paints or paint mixtures could be distinguished even by visual inspection: with just a few omissions, paints that occur in this test area represent the essential material from which the entire composition is created. With the aid of the two methods of noninvasive chemical imaging (HSI and, especially here, macro-XRF), the number of paints in this test area was expanded such that twenty-five separate paint applications could be identified, as indicated in figure 54, which can be compared directly with the elemental maps generated by macro-XRF scanning (fig. 55). Here, in the detail shown in figure 54, we see most of the paints that comprise the substance of *Mural.* In our interpretation, the creation of the painting seems to fall into three main phases: (1) an initial laying in of the skeletal structure of the composition, which is done in four differently colored paints—lemon yellow, dark teal, cadmium red, and umber—each thinned down and applied thinly and broadly in sweeping, dynamic gestures; (2) an extended "solidification" phase featuring a variety of paint types and modes of application—broad brush, narrow brush, splattering, flicking—that add the definition and detail to the framework established in the initial phase; and (3) a single phase of late retouching that Pollock adds after the painting is photographed, mid-process, in his studio (see fig. 27).

It is easiest, perhaps, to consider these three general phases in reverse, descending order. First we see paints associated with the campaign of late retouchings by Pollock: a pale flesh color **1** over an opaque white **2** that is the standard mixture titanium white and zinc white,[1] the dark green-blue **3** that is rich in viridian (hydrated chromium oxide) and cobalt blue with a little umber,[2] and this in turn lies over late applications of the gray-green paint **4** , a complex mixture of many pigments. Dark green-blue paint **3** occurs as the uppermost paint layer in cross-section samples, such as that illustrated in figure 42a. Probably also part of the late edits/retouching is pale warm yellow **5** .

All of the paints (**1** through **5**) connected with the final retouching campaign can be seen to lie on top of those connected with the main solidification phase in which Pollock added much of the detail of the composition, using a variety of different paints and means of application.

93

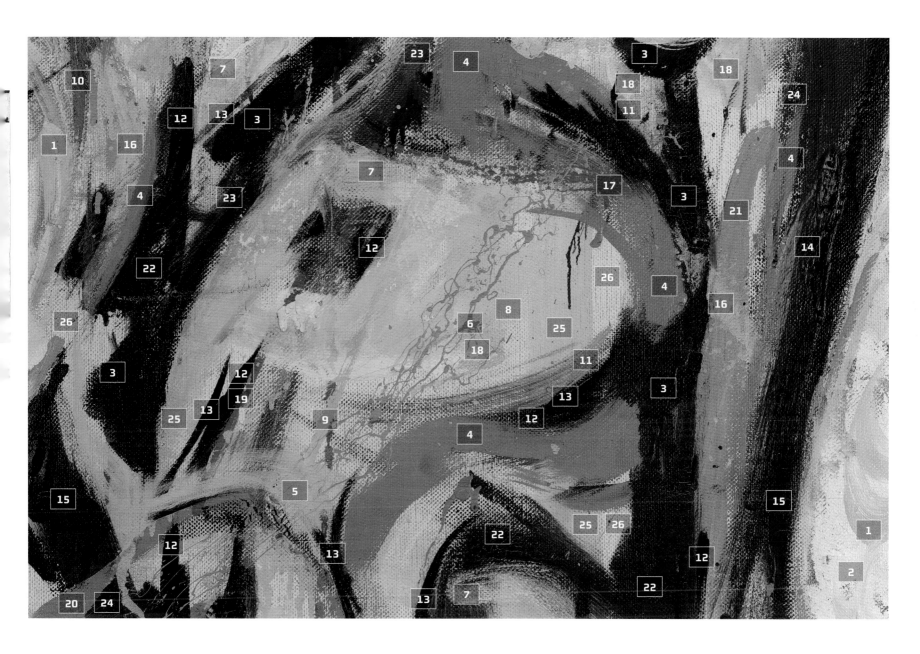

ELEMENTAL MAPS
MACRO-XRF SCANNING

FIGURE 55
Elemental maps showing the distributions of various
elements that, either alone or in combination, are indicative
of specific pigments. (See text for discussion.) Images
by Gert van der Snickt, University of Antwerp, Belgium

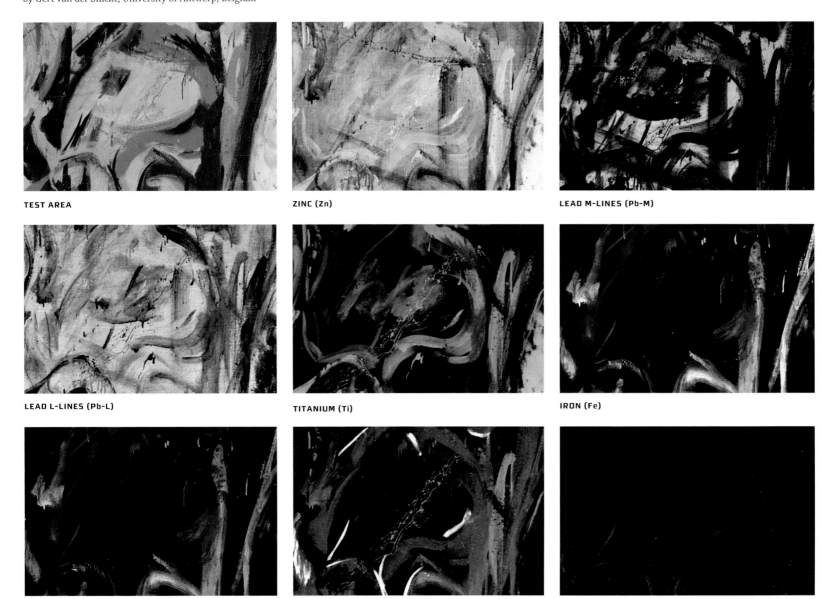

TEST AREA **ZINC (Zn)** **LEAD M-LINES (Pb-M)**

LEAD L-LINES (Pb-L) **TITANIUM (Ti)** **IRON (Fe)**

MANGANESE (Mn) **CALCIUM (Ca)** **PHOSPHORUS (P)**

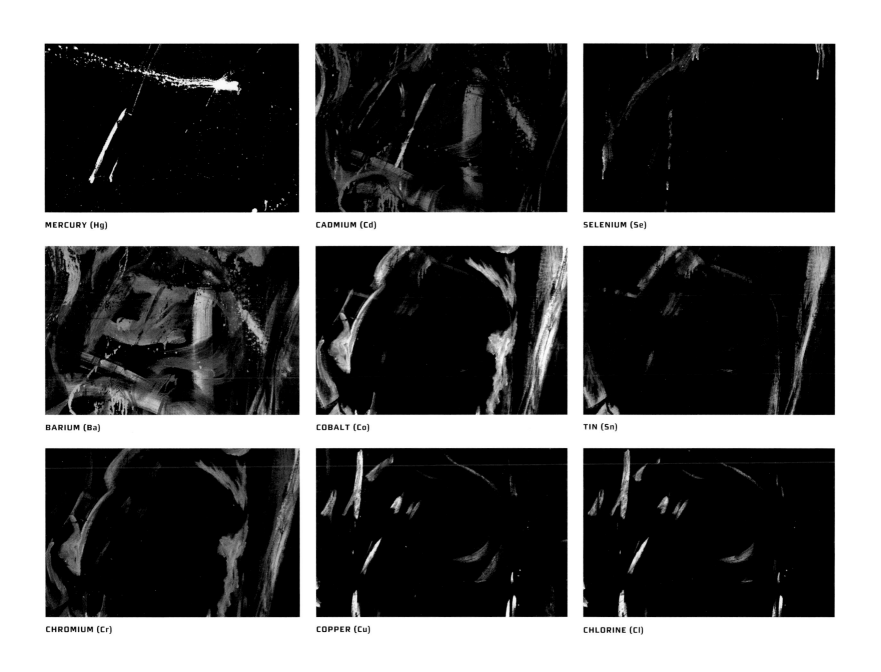

MERCURY (Hg)

CADMIUM (Cd)

SELENIUM (Se)

BARIUM (Ba)

COBALT (Co)

TIN (Sn)

CHROMIUM (Cr)

COPPER (Cu)

CHLORINE (Cl)

In roughly descending order, we see the stringy, viscous pink paint applied by flicking from the brush 6 ,[3] upper applications of the (lithopone and silicates) retail trade paint 7 [4] over a pale (cadmium) lemon yellow tint 8 (cadmium yellow and Ti/Zn whites),[5] which in turn lies over a warm (cadmium) medium yellow 9 .[6] Also in this phase there are short strokes of light phthalocyanine blue 10 and phthalo green 11 tints,[7] plus phthalo green at full strength 12 [8] and a black 13 that contains bone black[9] with a little umber. In this phase, too, is strong medium blue 14 that is rich in cobalt blue, which overlies a midlevel application of dark brown umber 15 with some bone black.[10] These paint layers lie over two separate campaigns of brush splattering of very diluted paint: the upper (later) one is a (cadmium) lemon yellow 16 ;[11] the lower (earlier) one is vermilion 17 .[12] Although its position in the sequence of paint applications is here difficult to determine with certainty, there appears to be a separate earlier application 18 of the (lithopone and silicates) retail trade paint than paint 7 described above; this early house paint application 18 certainly lies over some linear strokes in vermilion paint 19 . The cadmium lemon splattered paint lies on top of an early application of both the gray-green 20 and the brushed pink paint 21 composed of alizarin crimson and Ti/Zn whites.[13] Comparison of these two paints across the picture surface indicates that the pink 21 is usually beneath the first gray-green 20 , suggesting earlier application of the brushed pink.

Probing deeper into the lowest sequence of paint applications becomes quite a challenge because of the coverage of the later layers. However, it is possible to identify four paints that make up phase (1), the very earliest applications that serve as the platform for the eventual composition. In descending order, these are a pure umber 22 ,[14] a cadmium (sulfoselenide) red 23 ,[15] a dark teal color 24 that is rich in cerulean blue (cobalt stannate),[16] and a strong cadmium lemon (cadmium sulfide and barium sulfate) 25 .[17] These four paints have some features in common: they are all quite thinly applied with a moderately broad brush (approx. 2 in. wide); they are all clearly quite fluid, evidently thinned with solvent; and they all seem to have been applied close together in time, as evidenced by frequent occurrences of in situ wet-in-wet interaction where they cross or overlap. We suggest that these four paints are associated with Pollock's first broad gestures that laid in the essential structure of the painting. The umber paint 22 is clearly associated with the stick-figure Bentonian architecture, but it appears not to be the first paint application. In this test area and elsewhere, the umber paint 22 can be seen to lie over at least the cadmium lemon 25 , if not also the dark teal 24 , a sequence that is also encountered in cross-section paint samples. Rather surprisingly, the broad strokes in thinned-down bright cadmium lemon paint 25 appear to be Pollock's first interventions on the blank white priming 26 of the canvas,[18] which remains exposed in many areas to provide the light background on which the myriad colored shapes are set.

All of the paints described above are in a medium of drying oil, with the exception of the two applications of the (lithopone and silicates) retail trade paint (paints 7 and 18), which are in a water-based casein medium.

Macro-XRF scanning of the area illustrated in figure 54 generated the elemental maps shown in figure 55. The distribution of particular pigments may be illustrated directly in the map for a single element—for example, the image for mercury corresponds exactly to the horizontal splatter of scarlet red, which is vermilion—or by cross comparison of the maps for multiple elements—for example, calcium and phosphorus show the occurrences of bone black.

NOTES

1. See the elemental maps for titanium (Ti) and zinc (Zn) for the coincident abundance of titanium and zinc white within the test area, taking into account that zinc white also occurs as the first ground layer.
2. See the overlap in the distributions of chromium (Cr) and cobalt (Co) in the respective elemental maps.
3. Note the abundance of calcium in this paint (also in pink paint #21), which is related to calcitic extenders associated with the alizarin crimson lake pigment.
4. See the elemental map for barium (Ba) coming from the lithopone pigment present.
5. See the elemental maps for titanium (Ti), zinc (Zn), barium (Ba), and cadmium (Cd).
6. See the elemental map for cadmium (Cd).
7. See the elemental map for copper (Cu).
8. See the overlap in the distributions of chlorine (Cl) and copper (Cu) in the respective elemental maps.
9. See the overlap in the distributions of calcium (Ca) and phosphorus (P) in the respective elemental maps.
10. See the overlap in the distributions of iron (Fe), manganese (Mn), calcium (Ca), and phosphorus (P) in the respective elemental maps.
11. See the overlap in the distributions of barium (Ba) and cadmium (Cd).
12. See the elemental map for mercury (Hg).
13. See the overlap in the distributions of titanium (Ti), zinc (Zn), and calcium (Ca) in the respective elemental maps. The calcium is associated with the alizarin crimson lake pigment that makes the pink color.
14. See the overlap in the distributions of iron (Fe) and manganese (Mn).
15. See the overlap in the distributions of cadmium (Cd) and selenium (Se).
16. See the overlap in the distributions of cobalt (Co) and tin (Sn) in the respective elemental maps.
17. See the overlap in the distributions of barium (Ba) and cadmium (Cd).
18. See, especially, the map corresponding to the M-series electron transition for lead (Pb-M).

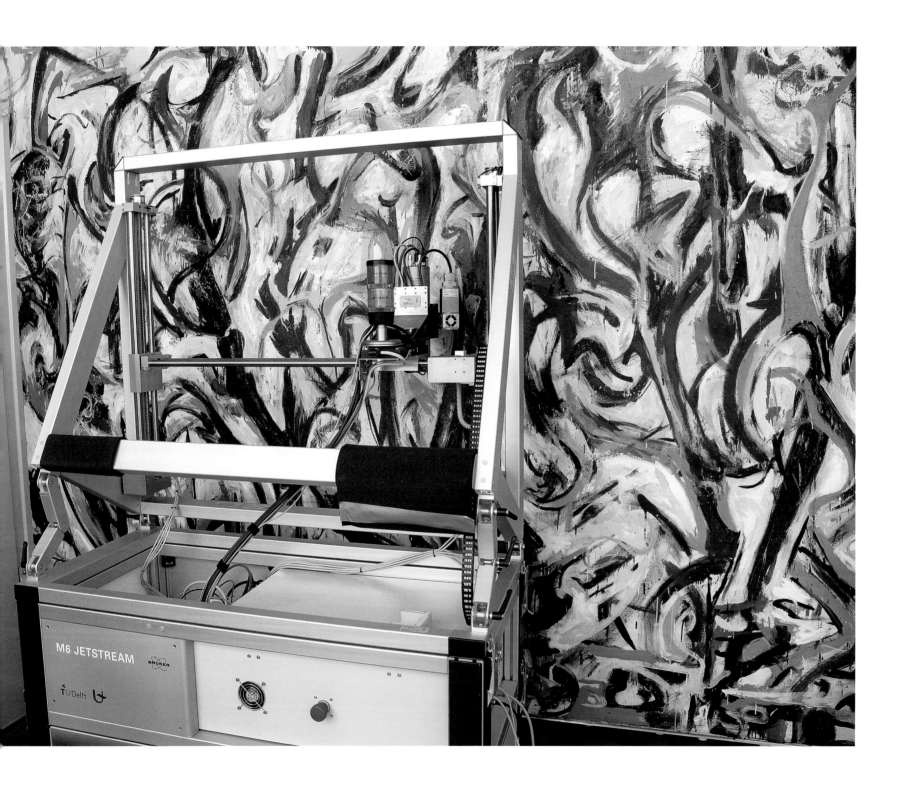

APPENDIX

SCIENTIFIC METHODS AND INSTRUMENTATION

PREPARATION AND EXAMINATION OF CROSS-SECTION SAMPLES

The fragments of samples selected for examination as cross sections were mounted in Technovit 2000 LC resin (a UV-curing acrylic) and polished by hand. The prepared cross-section samples were examined under visible light and by ultraviolet fluorescence using a Leica DM4000 microscope. Digital images were captured using a Diagnostic Instruments Flex camera. Elemental analysis was subsequently performed on the cross-section samples using ESEM-EDS, and Raman microspectroscopy was performed on selected cross-section samples to confirm the identity of particular pigment compounds.

ANALYSES

ESEM-EDS

Environmental scanning electron microscopy with energy-dispersive X-ray spectroscopy was performed on cross-section samples using a Philips XL30 instrument fitted with an Oxford Instruments INCA EDS analysis system. The EDS analysis was done under standard ESEM conditions: H_2O mode, 10 mm, 20 kV accelerating voltage, 0.8–1.0 torr water vapor pressure. ESEM-EDS analysis is capable of providing data on the elemental composition of specific target sites in samples; these target sites may be single points or larger areas of interest, and provision exists in the INCA software for mapping of the distribution of specific elements if desired. ESEM-EDS analysis allows identification of the elemental composition of the sample and visualization of the distribution of elements within the sample. In many instances, the presence and/or combination of indicative elements can, by inference, provide a reliable indication of the identity of a constituent pigment. Backscattered electron (BSE) images of the samples obtained by electron microscopy analysis are useful for comparison with the optical images of the cross sections.

Macro-XRF scanning of *Mural* in progress. The measuring head containing the X-ray source and spectrometer, which is mounted on an X,Y translation stage, scans across the selected test area in small increments, gathering X-ray fluorescence spectra with each incremental displacement. The spectral data is computer processed to generate images that represent maps of the distributions of elements within the scanned area, from which the presence of particular pigments can be inferred.

FTIR MICROSPECTROSCOPY

Fourier-transform infrared spectroscopy is an instrumental analytical method that can provide information on the composition of organic substances and some inorganic compounds. FTIR spectrometers measure the energies (usually expressed as wavenumbers, \bar{v}, in units of cm^{-1}) of vibrational and rotational transitions in the molecular bonds, which correspond to the infrared part of the electromagnetic spectrum. The primary output from the spectrometer is an FTIR spectrum, typically covering the wavenumber range 600–4000 cm^{-1}, the peak patterns of which are connected to particular bond vibrations and rotations. Accordingly, the FTIR spectrum can provide a more or less specific fingerprint of the functional groups present within the sample. Identification of particular substances in the sample is usually achieved by comparison of the spectrum, or selected parts of it, with reference spectra. In FTIR microspectroscopy, the spectrometer is coupled to an optical microscope, which allows spectra to be acquired from particular parts of the sample, giving a degree of fine spatial resolution to the analysis. In the FTIR analyses of samples from Pollock's *Mural*, small fragments from the stock of sample material were placed on a diamond window and flattened using a metal roller. The samples were examined in transmission mode using a Bruker Hyperion 3000 FTIR microscope (15× Cassegrain objective) coupled to a Vertex 70 FTIR spectrometer; purging was done with dry air. The instrument features a liquid nitrogen–cooled mid-band mercury cadmium telluride (MCT) detector. The spectra collected were the sum of 64 scans at a resolution of 4 cm^{-1}. Reference spectra from several infrared spectral databases were utilized in the identification process.

RAMAN MICROSPECTROSCOPY

Raman (micro)spectroscopy is another type of vibrational spectroscopy that operates in the infrared region; it exploits the weak, inelastic "Raman" scattering effect of photons. The outputs from a Raman spectrometer are spectra that comprise peaks at specific energies (again usually expressed as wavenumbers, \bar{v}, in units of cm^{-1}). Coupled with an optical microscope, Raman microspectroscopy using laser excitation allows for spatially resolved analysis by reflection, from mounted or unmounted samples. In the work presented here, spectra were acquired using a Renishaw inVia Raman microscope using 785 nm laser excitation at 50× objective power; laser power and other collection parameters were varied for each area examined to optimize the signal while avoiding sample degradation. Spectra were calibrated using the 520.5 cm^{-1} line of silicon. Substance identifications were made by comparing the analyte spectrum to those of reference materials or to spectral libraries and published data sets.

BINDING MEDIUM ANALYSIS

Identifications of organic binding media in samples from *Mural* were made using various forms of the instrumental technique of gas chromatography coupled with mass spectrometry (GC/MS). These methods are capable of analyzing complex mixtures of substances; they function essentially by first separating the various molecular constituents in the gas chromatograph and then breaking up those molecules into fragments that are characteristic of their precursor compounds. Two different modes of GC/MS were employed in the analysis of organic components in samples from *Mural*: GC/MS with preliminary chemical derivatization (using protocols specific to oils/resins/waxes and proteins, respectively) and pyrolysis (Py)-GC/MS for resins, oils, and polymers. The specific methods and conditions used in each case were as follows:

GC/MS Oils. 100 μl of a solution of Meth Prep II reagent (0.2N *m*-trifluoromethylphenyl trimethylammonium hydroxide in methanol) in toluene (1:2) were added to the vials. The vials were warmed on a hotplate at 60°C for 1 hr. After cooling, the vials were centrifuged, and the contents were ready for injection into the GC/MS instrument (Agilent Technologies 6890N). An INNOWax (25 m × 0.2 mm × 0.2 μm) capillary column was used for the separation. Helium carrier gas was set to a linear velocity of 44 cm/sec. Splitless injection was used with a 60 sec purge off time and was set to 260°C. The MS transfer line was set to 260°C. The GC oven temperature program was 80°C for 2 min; 10°C/min to 260°C; isothermal for 15 min; 20°C/min to 260°C; isothermal for 2 min. Total run time was 38 min.

GC/MS Proteins. 100 μl of a solution of 6N HCl was added to the reaction vials and heated for 24 hr at 105°C. This was evaporated and reconstituted in 25 mm HCl to a final volume of 60 μL, mixed with 32 μL ethanol, 8 μL pyridine, and 5 μL ECF (ethylchloroformate), then shaken for 5 sec and 100 μL 1% ECF in chloroform added. The chloroform layer was transferred into a vial, and the solution was extracted a second time, neutralized, concentrated, and injected into the GC/MS instrument (Agilent Technologies 6890N). An INNOWax (25 m × 0.2 mm × 0.2 μm) capillary column was used for the separation. Helium carrier gas was set to a linear velocity of 38.8 cm/sec, at 1 mL/min. Splitless injection was used with a 60 sec purge off time and was set to 240°C. The MS transfer line was set to 240°C. The GC oven temperature program was 70°C for 1 min; 20°C/min to 250°C; isothermal for 3.5 min. Total run time was 12 min.

Py-GC/MS. Pyrolysis gas chromatograph/ mass spectrometry analysis was carried out on a Frontier Lab PY-2020D double-shot pyrolyzer system attached to an Agilent Technologies 5975C inert MSD/7890A GC/MS instrument. Column: Frontier Ultra ALLOY-5 30 m (0.25 mm × 0.25 μm); helium carrier gas: 1 mL/min flow; GC oven: 40°C for 2 min, ramped 20°C/min to 320°C, then held at 320°C for 9 min; MS ionization: 70 eV. Samples were placed into a 50 μl stainless steel cup, and 3 μl of a 10% methanolic solution of tetramethyl ammonium hydroxide (TMAH) was introduced for derivatization. After 3 min, the cup was placed into the pyrolysis interface. Samples were pyrolyzed using a single-shot method at 550°C for 6 sec.

ANALYTICAL IMAGING

Thanks to the generous assistance of colleagues in other institutions, who provided instruments and expertise, two newly developed methods of analytical imaging—both forms of noninvasive imaging spectroscopy—were applied in the technical study of *Mural:* hyperspectral imaging (HSI) and macro-XRF scanning.

HYPERSPECTRAL IMAGING

Hyperspectral imaging can reveal the distribution of particular material constituents of works of art by virtue of their characteristic absorption and/or reflection properties in the visible and near-infrared regions of the electromagnetic spectrum. It is one of a range of new imaging spectroscopy techniques that have been pioneered, in part, by John Delaney, Senior Imaging Scientist at the National Gallery of Art, Washington, DC,

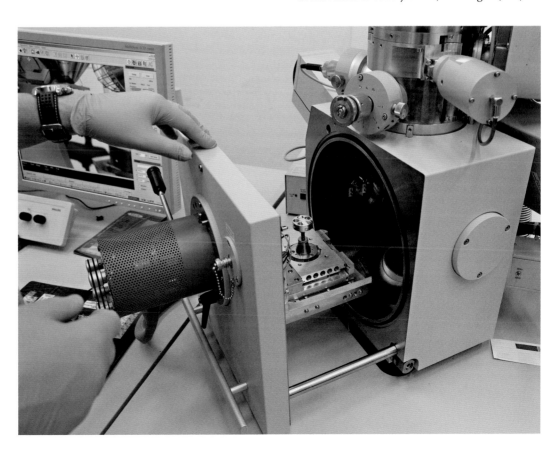

ESEM-EDS: A prepared cross-section sample, mounted in a small carousel, is loaded into the vacuum chamber of a scanning electron microscope in preparation for analysis. Inside the vacuum chamber are the various detectors of the instrument, including the X-ray spectrometer. The apparatus at the top of the instrument comprises the various components that generate and focus the electron beam directed at the sample.

and his coworkers.[1] Delaney himself performed the hyperspectral imaging of *Mural* in April 2013.

Mural was imaged using a novel "whisk-broom" scanning hyperspectral camera (720, Surface Optics, San Diego, CA) originally designed for terrestrial remote sensing. The focal plane is replaced with a high-sensitivity, low-noise InGaAs detector (Sensors Unlimited, Princeton, NJ). This modification allowed operation at low light levels (500 vs. 10,000 lux). The painting was illuminated using two 125 W tungsten halogen lamps at 45° angles from the right and left. *Mural* was scanned at 100 msec per line, and an image of 640 × 640 by 256 spectral channels was captured per image frame. To acquire the computed image cube, some 60 image cubes were mosaicked using novel software developed at George Washington University and the National Gallery of Art. The spectral range of the resulting cube was from 970 to 1700 nm with a 2.45 nm sample width. Total collection time was ~2 min per image cube. A white board was used as a flat field for each image for uniformity, and in-scene diffuse reflectance standards were used to calibrate to apparent reflectance. The final image was 7050 by 2558 pixels, which was aggregated 2× to do the processing (3525 by 1279 pixels).

Maps were made using ENVI software on a Mac workstation. The data were processed in two ways: first, the generally hyperspectral convex geometry algorithms were applied to find the minimum set of end members; second, end members were picked directly from sites in the painting for which the pigment composition was known from analysis of samples. The mapping of the pigments from these end members was done using a match filter approach. Specifically representative reflectance spectra of materials of interest were selected and the matched filtering (MF) algorithm applied. The MF algorithm returns a value on the degree of match. The images produced have the property of intensity, which is proportional to the degree of match. Low values—gray to black—represent a poor spectral match; higher values tending toward

white represent a correspondingly better match. Generally the data here are set from a range of 0.1 to 0.65 as recommended. Some images (e.g., that for cobalt blue) were median filtered using a 1 pixel filter in Photoshop. This removes single pixel high values that are likely noise. Correlation of spectral maps with specific pigments was done by comparison with a database of reference spectra or using identifications achieved by chemical analysis. For example, in the case of the retail trade, or house, paint, hydroxyl bands around 1400 nm associated with the silicate extenders provided the key to the mapping of that material. The cobalt blue and cerulean blue images were derived using library spectra. The images for phthalocyanine colors were derived using library spectra, but the separation between blue and green types was achieved by reference to the visible image. All hyperspectral images reproduced here have been inverted from their original form in order to present the distributions of specific colorants as dark shapes against a light background.

MACRO-XRF SCANNING

Macro-XRF scanning was performed using the novel M6 Jetstream instrument developed between the research groups of Koen Janssens at the University of Antwerp, Belgium, and Joris Dik at the Delft University of Technology, the Netherlands, in collaboration with Bruker Nano GmbH.[2] The M6 Jetstream consists of a measuring head that is moved over the surface of the painting by means of a programmable motorized X,Y translation stage. The measuring head consists of a 30 W rhodium-target microfocus X-ray tube with a maximum voltage of 50 kV and a maximum current of 0.6 mA. Sets of elemental distribution images are obtained from spatially resolved X-ray fluorescence spectra acquired by scanning the measuring head slowly in small increments (as low as 10 μm) over the region of interest. The images presented here were acquired by scanning the test area (approx. 58 × 39 cm) in 600 μm steps with a dwell-time of 90 msec. Tube settings were 40 kV and 0.5 mA. The whole scan process lasted well over 15 hr.

Outputs from the macro-XRF scanning are essentially series of maps of signal intensity related to the particular, characteristic electron transitions of individual elements. In effect the images are plots of the distribution of single elements across the scan area, from which the presence of particular pigments can be inferred, either directly or by cross comparison.

NOTES

1. See, for example, Paola Ricciardi, John K. Delaney, Michelle Facini, and Lisha Glinsman, "Use of Imaging Spectroscopy and In Situ Analytical Methods for the Characterization of the Materials and Techniques of 15th Century Illuminated Manuscripts," *Journal of the American Institute for Conservation* 52, no. 1 (2013): 13–29.

2. Matthias Alfeld, et al. "A Mobile Instrument for In Situ Scanning Macro-XRF Investigation of Historical Paintings," *Journal of Analytical Atomic Spectrometry* 28 (2013): 760–67.

BIBLIOGRAPHY

ARCHIVES

Archives of American Art, Smithsonian Institution, Jackson Pollock and Lee Krasner Papers

Getty Research Institute, Special Collections and Visual Resources, Clement Greenberg Papers

University of Delaware Library, Special Collections, Emily Holmes Coleman Papers

University of Iowa Museum of Art, Object Files

Yale University Art Gallery, Registrar's Office, Files

PUBLISHED WORKS AND INTERVIEWS

Adams, Henry. *Tom and Jack: The Intertwined Lives of Thomas Hart Benton and Jackson Pollock*. New York: Bloomsbury Press, 2009.

Alfeld, Matthias, et al. "A Mobile Instrument for In Situ Scanning Macro-XRF Investigation of Historical Paintings." *Journal of Analytical Atomic Spectrometry* 28 (2013): 760–67.

Anon. "Jackson Pollock: A Questionnaire." *Arts and Architecture* 61, no. 2 (February 1944): 14. Reprinted in Karmel, *Jackson Pollock: Interviews, Articles, and Reviews*, 15.

B[elle] K[rasne]. "Fifty-Seventh Street in Review: Jackson Pollock." *Art Digest* 25 (December 1, 1950): 16.

Benton, Thomas Hart. "The Mechanics of Form Organization in Painting." *Arts* 10 (November 1926): 285–89; 10 (December 1926): 340–42; 11 (January 1927): 43–44; 11 (February 1927): 95–96; 11 (March 1927): 145–48.

Brenson, Michael. "Stanley William Hayter, 86, Dies; Painter Taught Miro and Pollack [*sic*]." *New York Times,* May 6, 1988, 28.

Clark, T. J. "Pollock's Smallness." In *Jackson Pollock: New Approaches,* edited by Kirk Varnedoe and Pepe Karmel, 15–31. New York: Museum of Modern Art, 1999.

Coates, Robert M. [No title.] *New Yorker,* May 29, 1943, 49; November 20, 1943, 97–98; January 17, 1948, 56–57. Reprinted in Karmel, *Jackson Pollock: Interviews, Articles, and Reviews,* 50–51, 58–59.

Coddington, James. "No Chaos Damn It." In *Jackson Pollock: New Approaches,* edited by Kirk Varnedoe and Pepe Karmel 101–15. New York: Museum of Modern Art, 1999.

Dearborn, Mary V. *Mistress of Modernism: The Life of Peggy Guggenheim.* New York: Houghton Mifflin, 2004.

Farber, Manny. "Jackson Pollock." *New Republic,* June 25, 1945, 871–72. Reprinted in Karmel, *Jackson Pollock: Interviews, Articles, and Reviews,* 53–54.

Foster, Stephen. "Turning Points in Pollock's Early Imagery." *University of Iowa Museum of Art Bulletin* (Iowa City) 1, no. 1 (Spring 1976): 25–37.

Friedman, B. H. *Jackson Pollock: Energy Made Visible.* New York: McGraw-Hill, 1972.

Greenberg, Clement. "Art." *The Nation* 157 (November 27, 1943): 621. Reprinted in Karmel, *Jackson Pollock: Interviews, Articles, and Reviews,* 51.

———. "Art." *The Nation* 160 (April 7, 1945): 397. Reprinted in Karmel, *Jackson Pollock: Interviews, Articles, and Reviews,* 52.

———. "Art." *The Nation* 162 (April 13, 1946): 444–45.

———. "The Present Prospects of American Painting and Sculpture." *Horizon* 93 (October 1947): 25–26.

Guggenheim, Peggy. *Confessions of an Art Addict.* New York: Macmillan, 1960.

———. *Out of This Century: Confessions of an Art Addict.* New York: Universe Books, 1979.

———. *Out of This Century: The Informal Memoirs of Peggy Guggenheim.* New York: Dial Press, 1946.

Halasz, Piri. "Stanley William Hayter: Pollock's Other Master." *Arts Magazine* 59 (November 1984): 73–75.

Harris, Ed. *Pollock.* Culver City, CA: Brant-Allen Films/Columbia TriStar Home Entertainment, 2000.

Harrison, Helen, ed. *Such Desperate Joy: Imagining Jackson Pollock.* New York: Thunder's Mouth Press, 2000.

Hayter, Stanley William. *New Ways of Gravure.* New York: Pantheon, 1949.

———. "Paul Klee: Apostle of Empathy." *Magazine of Art* 39, no. 4 (April 1946): 127–30.

Herbst, Willy, and Klaus Hunger. *Industrial Organic Pigments: Production, Properties, Applications.* Weinheim: Wiley-VCH, 2004.

J[ames] R L[ane]. "Review of American and French Painting, McMillen Inc." *Art News* 40 (January 15–31, 1942): 29.

Karmel, Pepe, ed. *Jackson Pollock: Interviews, Articles, and Reviews.* New York: Museum of Modern Art, 1999.

Lake, Susan, Eugena Ordonez, and Michael Schilling. "A Technical Investigation of Paints Used by Jackson Pollock in His Drip or Poured Paintings." In *Modern Art, New Museums: Contributions to the Bilbao Congress, 13–17 September 2004,* edited by Ashok Roy and Perry Smith, 137–41. London: International Institute for Conservation, 2004.

Landau, Ellen G. "Action/Re-Action: The Artistic Friendship of Herbert Matter and Jackson Pollock." In *Pollock Matters,* edited by Ellen G. Landau and Claude Cernuschi, 9–58. Boston: McMullen Museum of Art, 2007.

———. *Jackson Pollock.* New York: Harry N. Abrams, 1989.

———. *Mexico and American Modernism.* New Haven: Yale University Press, 2013.

Lomax, Suzanne Quillen, and Sarah L. Fisher. "An Investigation of the Removability of Naturally Aged Synthetic Picture Varnishes." *Journal of the American Institute for Conservation* 29, no. 2 (Autumn 1990): 181–91.

Mancusi-Ungaro, Carol C. "Jackson Pollock: Response as Dialogue." In *Jackson Pollock: New Approaches,* edited by Kirk Varnedoe and Pepe Karmel, 117–20, 145–53. New York: Museum of Modern Art, 1999.

Naifeh, Steven, and Gregory White Smith. *Jackson Pollock: An American Saga.* New York: Clarkson N. Potter, 1989.

Newhouse, Victoria. *Art and the Power of Placement.* New York: Monacelli Press, 2005.

O'Connor, Francis V. "Jackson Pollock: Down to the Weave." In *Such Desperate Joy: Imagining Jackson Pollock,* edited by Helen Harrison, 177–94. New York: Thunder's Mouth Press, 2000.

———. "Jackson Pollock's *Mural* for Peggy Guggenheim: Its Legend, Documentation, and Redefinition of Wall Painting." In *Peggy Guggenheim and Frederick Kiesler: The Story of Art of This Century,* edited by Susan Davidson and Philip Rylands, 150–69. New York: Guggenheim Museum Publications, 2004.

———. "A Note about Murals." In *Pollock: A Catalogue Raisonné of Paintings, Drawings, and Other Works, Supplement Number 1,* 52–53. New York: Pollock-Krasner Foundation, 1995.

O'Connor, Francis V., and Eugene Victor Thaw, eds. *Jackson Pollock: A Catalogue Raisonné of Paintings, Drawings, and Other Works.* 4 vols. New Haven: Yale University Press, 1978.

O'Hara, Frank. *Jackson Pollock.* New York: George Braziller, 1959.

Polcari, Stephen. "Jackson Pollock and Thomas Hart Benton." *Arts Magazine* 53 (March 1979): 120–24. Reprinted without illustrations in Karmel, *Jackson Pollock: Interviews, Articles, and Reviews,* 193–201.

Pollock, Jackson. "Interview with William Wright." The Springs, 1950, radio station WERI, Westerly, RI, 1951. Reprinted in Karmel, *Jackson Pollock: Interviews, Articles, and Reviews,* 20–23.

———. "My Painting." *Possibilities* 1 (Winter 1947–48): 83. Reprinted in Karmel, *Jackson Pollock: Interviews, Articles, and Reviews,* 18.

Potter, Jeffrey. Audiotaped interview. East Hampton, NY, June 11, 1983. Pollock-Krasner House and Study Center.

———. *To a Violent Grave: An Oral Biography of Jackson Pollock.* New York: G. P. Putnam's Sons, 1985.

Pratt, Lyde S. *The Chemistry and Physics of Organic Pigments.* New York: J. Wiley and Sons, 1947.

Radcliffe, Robert S. "Casein Paints." In *Protective and Decorative Coatings*, vol. 3, edited by Joseph J. Mattiello, 461–81. New York: Wiley, 1943.

Ricciardi, Paola, John K. Delaney, Michelle Facini, and Lisha Glinsman. "Use of Imaging Spectroscopy and In Situ Analytical Methods for the Characterization of the Materials and Techniques of 15th Century Illuminated Manuscripts." *Journal of the American Institute for Conservation* 52, no. 1 (2013): 13–29.

Riley, Maude. "Fifty-Seventh Street in Review: Explosive First Show." *Art Digest* 18 (November 15, 1943): 18. Reprinted in Karmel, *Jackson Pollock: Interviews, Articles, and Reviews,* 50.

Rodman, Selden. *Conversations with Artists.* New York: Devin-Adair, 1957.

Rohn, Matthew L. *Visual Dynamics in Jackson Pollock's Abstractions.* Ann Arbor, MI: UMI Research Press, 1987.

Rose, Barbara. "Jackson Pollock at Work: An Interview with Lee Krasner." *Partisan Review* 47, no. 1 (1980): 82–92. Reprinted in Karmel, *Jackson Pollock: Interviews, Articles, and Reviews,* 39–47.

Rose, Bernice. *Jackson Pollock: Drawing into Painting.* International Council of the Museum of Modern Art, New York. Oxford: Museum of Modern Art, Oxford, and the Arts Council of Great Britain, 1979.

Rosenberg, Harold. "The American Action Painters." *Art News* 51 (December 1952): 22–23, 48–50.

———. "The Art World: The Mythic Act." *New Yorker,* May 6, 1967, 162–71.

Rubin, William. "Jackson Pollock and the Modern Tradition" and "Jackson Pollock and the Modern Tradition: Part II: The All-Over Composition and the So-Called Drip Technique." *Artforum* 5, no. 6 (February 1967): 14–22; 5, no. 7 (March 1967): 28–37; 5, no. 8 (April 1967): 18–31; 5, no. 9 (May 1967): 28–33. Reprinted without illustrations in Karmel, *Jackson Pollock: Interviews, Articles, and Reviews,* 118–75.

Standeven, Harriet. *House Paints, 1900–1960: History and Use.* Los Angeles: Getty Conservation Institute, 2011.

Sweeney, James Johnson. "New Directions in Gravure: Hayter and Studio 17." *Bulletin of the Museum of Modern Art* 12 (August 1944): 3–5.

Varnedoe, Kirk, and Pepe Karmel, eds. *Jackson Pollock: New Approaches.* New York: Museum of Modern Art, 1999.

Varnedoe, Kirk, with Pepe Karmel. *Jackson Pollock.* [Catalogue of an exhibition held at the Museum of Modern Art, New York, November 1, 1998–February 2, 1999, and the Tate Gallery, London, March 11–June 6, 1999.] New York: Museum of Modern Art, 1998.

Weld, Jacqueline Bograd. *Peggy, the Wayward Guggenheim.* New York: E. P. Dutton, 1986.

Williams, Reba, and Dave Williams. "The Prints of Jackson Pollock." *Print Quarterly* 5, no. 4 (1988): 346–73.

ACKNOWLEDGMENTS

The work that has culminated in this publication and the associated exhibition of the University of Iowa's Jackson Pollock *Mural* at the Getty has been a complex undertaking involving many people. The conservation and display of the enormous canvas painting at the Getty was the brainchild of Pamela White, former director of the University of Iowa Museum of Art, an idea enthusiastically pursued by her successor, Sean O'Harrow. He and his colleagues in Iowa, including Kathleen Edwards, chief curator; Jeff Martin, manager of exhibitions and collections; Steve Erickson, head preparator; Katherine Wilson, assistant registrar; Diane Scott, accountant; and many others, have been generous and supportive partners throughout the project.

The conservation and technical study began as a collaborative venture of the J. Paul Getty Museum's (JPGM's) Paintings Conservation Department and the Getty Conservation Institute's (GCI's) Modern and Contemporary Art Research Initiative, and we offer sincere thanks to senior staff in both Getty programs, the JPGM and the GCI, for their support of the project: Timothy Potts, Timothy P. Whalen, Thomas Kren, and Jeanne Marie Teutonico. Scott Schaefer, the JPGM's senior curator of paintings, offered valuable contributions and insights at every step along the way. The conservation treatment could not have been executed without the assistance of many colleagues at the Getty who supported and participated in the work with admirable enthusiasm, especially Gene Karraker, Lauren Bradley, Sue Ann Chui, Devi Ormond, Johanna Ellersdorfer, Claire Toussat, and Laura Satterfield in Paintings Conservation. Particularly noteworthy is the work of Michael Smith, Stacey Rain Strickler, and Rebecca Vera-Martinez in Imaging Services, whose beautiful images are seen throughout this book. At the GCI, Wendy Lindsey and Joy Mazurek undertook a substantial amount of instrumental chemical analysis, the results of which allowed us to gain a detailed picture of the paint media Pollock used in the

creation of *Mural*; excellent reconstructions of the artist's distinctive mode of paint splattering were made by Kristi Parenti-Kurttila and Julia Langenbacher. Gary Mattison provided invaluable help at every step.

The Getty Research Institute (GRI) has also been involved in activities connected with *Mural*, and we would like to express our appreciation to Thomas Gaehtgens, Andrew Perchuk, and Aleca Le Blanc, enthusiastic colleagues who offered insights and countenance throughout the project. We look forward to working with them in connection with a symposium and publication focusing on Pollock. We are extremely grateful also to the Andrew W. Mellon Foundation for its generous grant that allowed us to bring colleagues from around the world into our discussions and deliberations on art historical and technical matters concerning the painting.

The logistical challenges associated with the transport, treatment, and exhibition of a painting of this scale cannot be overestimated. Registrars Sally Hibbard, Betsy Severance, Grace Murakami, Cherie Chen, and Kanoko Sasao at the Getty worked with many colleagues at the University of Iowa, including Katherine Wilson and Diane Scott, and together they expertly handled the logistics and administrative details.

Kevin Marshall and his preparations team were key players throughout the process, and we owe them enormous gratitude for their expert handling of the piece during its time in the JPGM, from arrival to installation in the gallery. Machinist Butch Green was especially helpful in fabricating numerous items that were needed for the painting's support and conservation treatment, and Michael Mitchell and his team lent invaluable aid at numerous moments. Tony Moreno and Loren Vincent designed and fabricated the new stretcher as well as the table needed for the structural treatment; we are indebted to them for their impeccable craftsmanship and enthusiastic participation in these important aspects of the painting's conservation. Andrew Gavenda was instrumental for his assistance with the packing of the painting in Iowa, and Rita Gomez (with Andrew) produced the packing crate with characteristic superb attention to detail.

The exhibition is a testament to the dedication and expertise of the JPGM's Exhibitions Department. We acknowledge its important contributions and specifically thank Quincy Houghton and Amber Keller for their diligence, patience, and encouragement throughout the process of organizing the exhibition. The JPGM's Design Department played a central role in the Getty's presentation of *Mural*, and we offer special thanks to Merritt Price, Irma Ramirez, and their team, especially Julie Sears and Catherine Bell, for their creative and innovative approach to presenting the painting and the accompanying didactic materials. Special thanks also go to the staff of the JPGM's Education Department, particularly Toby Tannenbaum and Tuyet Bach, for their help in preparing the gallery texts; likewise we are indebted to Stanley Smith, Erik Bertellotti, Nina Diamond, Sahar Tchaitchian, and Candice Lewis for their work in developing didactic content for electronic media, as well as to Maria Gilbert and others who have presented the project on the Web.

We are truly indebted to the JPGM's Paintings Conservation Council for its generous support of the exhibition, which has allowed us to present the analysis in innovative ways.

In the course of our research on *Mural*, we have been fortunate in being able to exchange information and knowledge with other specialists and in being welcomed by many of them in their institutions. In this connection, we are particularly indebted to Jim Coddington, Jennifer Hickey, and Ana Martins, Museum of Modern Art, New York; Carol Mancusi-Ungaro, Whitney Museum of American Art, New York, and Center for the Technical Study of Modern Art, Harvard Art Museums, Cambridge; Isabelle Duvernois, Julie Arslanoglu, Michael Gallagher, and Silvia Centeno, Metropolitan Museum of Art, New York; Carol Stringari, Susan Davidson, Gillian McMillan, and Julie Barten, Solomon R. Guggenheim Museum, New York; Luciano Pensabene Buemi, Peggy Guggenheim Collection, Venice; Nicholas Dorman, Seattle Art Museum; Susan Lake, Hirshhorn Museum and Sculpture Garden, Washington, DC; Gunnar Heydenreich, CICS—Cologne Institute of Conservation Sciences; Jay Krueger, National Gallery of Art, Washington, DC; Terry Mahon, New York; Jos van Och, Stichting Resauratie Atelier Limburg, Maastricht; Frank Zuccari, Art Institute of Chicago; George Baker, Joanna Fiduccia, and Natilee Harren, University of California, Los Angeles; Peter Sacks, Harvard University, Cambridge; Richard Tuttle; Charles Ray; John Baldessari; Analia Saban; Emily Warner, University of Pennsylvania, Philadelphia; Tatanya Thompson, Los Angeles; and Megan Luke, University of Southern California, Los Angeles. We are particularly indebted to John Delaney of the National Gallery of Art in Washington for making time in his busy schedule in order to do the very valuable and innovative hyperspectral imaging on *Mural*. We are also especially grateful to Joris Dik of the Delft University of Technology, the Netherlands, and Koen Janssens of the University of Antwerp, Belgium, whose joint research group kindly loaned the macro-XRF scanning instrument that generated the wonderful elemental maps of the paint on *Mural* that are presented in this volume. Special thanks, too, go to Geert van der Snickt, University of Antwerp, Belgium, who did the first set of XRF scans and kindly processed the data to generate the final images.

Helen A. Harrison, director of the Pollock-Krasner House and Study Center, graciously received us in The Springs, New York, allowing us access to archival material and sharing with us innumerable insights about the artist. Angelica Rudenstine generously shared her extensive research and knowledge of the Guggenheim townhouse, and her archival images proved to be especially informative and relevant; her insights and thoughts about the project were greatly appreciated as well. We are grateful to Alex Matter for his generosity toward this project, and thank Tim Noakes at the Department of Special Collections and University Archives, Stanford University Libraries, and Jeffrey Head for their assistance with materials from The Herbert Matter Archive.

Many more people at the Getty contributed to this project in various ways, including Patricia Woodworth, Tim Child, John Giurini, Kathleen Gaines, Carolyn Simmons, and Tisha

Greenwood. Also to be thanked are Ron Hartwig, Melissa Abraham, Amy Hood, Amra Schmitz, Ivy Okamura, Maureen McGlynn, Maria Velez, Bob Combs, Raj Kumar, Thomas Stewart, and Chloe Simon.

Kara Kirk of Getty Publications enthusiastically supported the book, and the incredible team from that department should be commended for their insights and patience. We thank them all, especially Elizabeth Nicholson, Suzanne Watson, Ruth Evans Lane, and Pam Moffat. We are particularly grateful to Jim Drobka for his beautiful design of the book, which is self-evident. And we thank Sheila Berg for her deft copyediting of the manuscript and Gregory Dobie for his attentive proofreading. We also salute our coauthors, Steve Martin and Ellen Landau, both for their wonderful essays and for their invaluable contributions to our thoughts about the painting.

Last, but not least, we are indebted to Jim Cuno for his enthusiastic support of the project from the very beginning. His commitment to the undertaking and his interest in the painting were profoundly present at every step, ensuring the success of the collaboration.

Yvonne Szafran, Laura Rivers, Alan Phenix, and Tom Learner

INDEX

Jackson Pollock's *Mural* is on view at the J. Paul Getty Museum at The Getty Center, Los Angeles, from March 11 to June 1, 2014.

PUBLISHED BY THE J. PAUL GETTY MUSEUM, LOS ANGELES

Getty Publications
1200 Getty Center Drive, Suite 500
Los Angeles, California 90049-1682
www.getty.edu/publications

Elizabeth S.G. Nicholson and Ruth Evans Lane, *Editors*
Sheila Berg, *Manuscript Editor*
Jim Drobka, *Designer*
Suzanne Watson, *Production Coordinator*

Stacey Rain Strickler and Rebecca Vera-Martinez, *Senior Photographers*
Michael Smith, *Studio Manager/Imaging Specialist*

Printed by Trifolio in Verona, Italy

Library of Congress Cataloging-in-Publication Data

Jackson Pollock's Mural : the transitional moment / Yvonne Szafran, Laura Rivers, Alan Phenix, Tom Learner, Ellen Landau and Steve Martin.
 pages cm
 Includes bibliographical references and index.
 ISBN 978-1-60606-323-1 (hardcover)
1. Pollock, Jackson, 1912–1956. Mural. 2. Pollock, Jackson, 1912–1956—Criticism and interpretation. 3. Abstract expressionism—United States. 4. Painting—Conservation and restoration—California—Los Angeles. I. Szafran, Yvonne, author. II. Pollock, Jackson, 1912–1956, artist. III. Martin, Steve, 1945– That Goddam surface. IV. J. Paul Getty Museum.
 ND237.P73A68 2014
 759.13—dc23
 2013042007